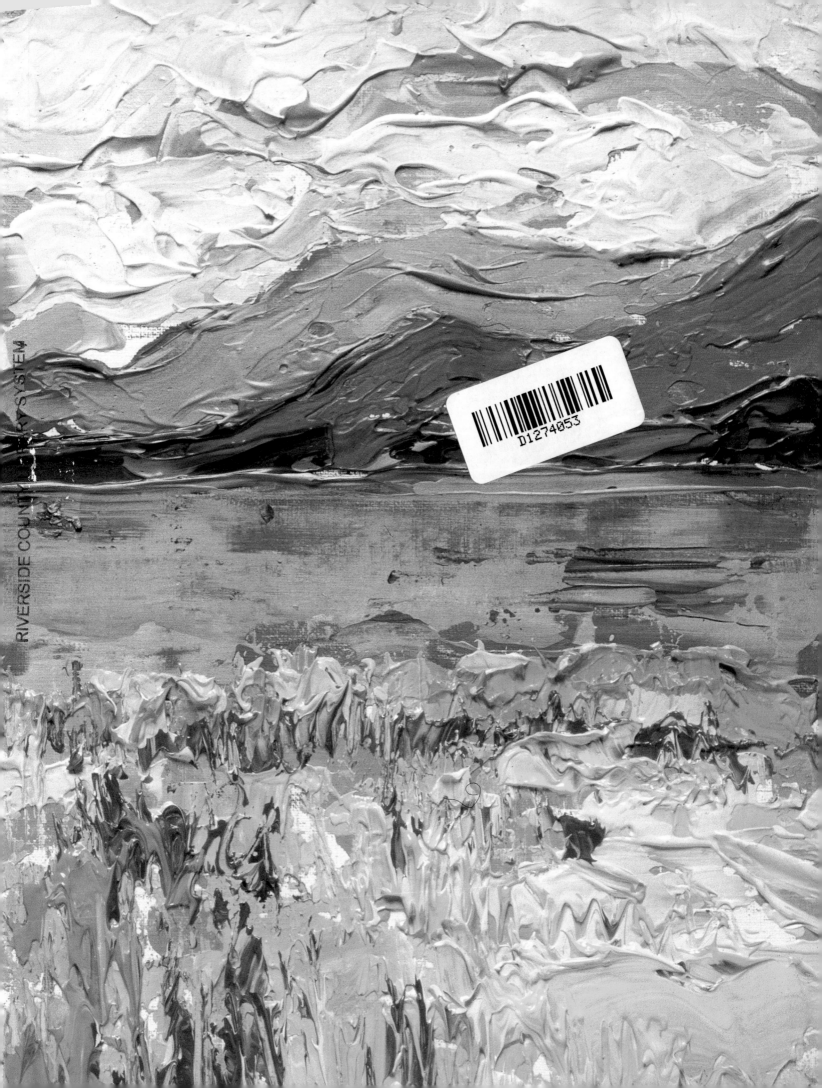

Acrylic
Painting

BARRON'S

Acrylic Painting

English language edition for the United States, its territories and dependencies, and Canada published in 2010 by Barron's Educational Series, Inc.
© Copyright of the English edition 2010 by Barron's Educational Series, Inc.
Original title of the book in Spanish: *Pintura al Acrylico.*

© Copyright Parramón Ediciones, S.A. 2007—World Rights
Published by Parramón Ediciones, S.A.
Ronda de Sant Pere, 5, 4a planta 08010 Barcelona, Spain
Author: Parramón's Editorial Team
Editor-in-chief: María Fernanda Canal
Editor: Tomás Ubach
Editorial assistant and image archive: Ma Carmen Ramos
Text: Gabriel Martín Roig
Drawings and Exercises: Gabriel Martín Roig, Óscar Sanchís, Almudena Carreño, Anna Llimós, Álex Sagarra
Photography: Nos & Soto

English Translation: Michael Brunelle and Beatríz Cortabarria

All inquiries should be addressed to:
Barron's Educational Series, Inc.
250 Wireless Boulevard
Hauppauge, New York 11788
www.barronseduc.com

ISBN-13: 978-0-7641-6274-9
ISBN-10: 0-7641-6274-8

Library of Congress Catalog Card No.: 2009936125

Printed in China
9 8 7 6 5 4 3 2 1

Acrylic
Painting

Con-
tents

Acrylic Painting

From the Industrial to the Artistic

The first experiments with acrylic paint were carried out in the 19th century, but they were not widely used until well into the 20th century. Beginning in 1930 acrylic paints were manufactured and distributed for industrial use only. Ten years later, Mexican and American artists, who were great experimenters, found this new material to be ideal for creating more subversive, more daring paintings, and very useful for large formats. Thus, a paint that was developed for industrial purposes was incorporated into the art world. With the passing of years, artists have discovered many technical advantages of acrylic paint, and have recognized its clear benefits, like the stability of its colors and its speed in drying.

For decades, the comparisons between acrylics and other, more traditional painting media were inevitable. Today, acrylic paint has its own identity, and is no longer compared to other techniques, nor is it utilized solely to imitate the effects of oil and watercolor.

Acrylics are popular because of their enormous creative potential and extreme versatility. Despite this, novice painters usually do not use them, perhaps because there are unfounded arguments that encourage painters to stay away from them. Beginners usually start their training as painters with oil colors. However, it is a good idea to begin practicing mixing colors and shades with acrylics, since they do not require a long drying time. One common characteristic of the beginner is impatience; many times he or she will not allow the paint enough time to dry and colors will run together and mix on the surface of the canvas. The results are muddied colors and indistinct brushstrokes. To summarize, the main virtues of acrylic paint are purity of color and a short drying time. It is no coincidence that today there are a great many artists using acrylics.

Acrylics were developed as industrial paint, but became so popular that they are now one of the most widespread painting media because of the purity of their colors and their quick drying time.

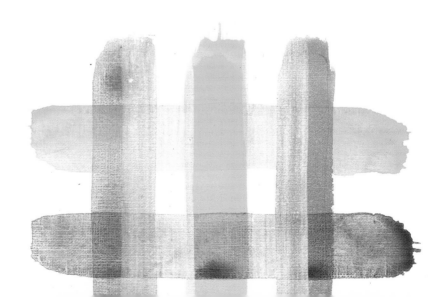

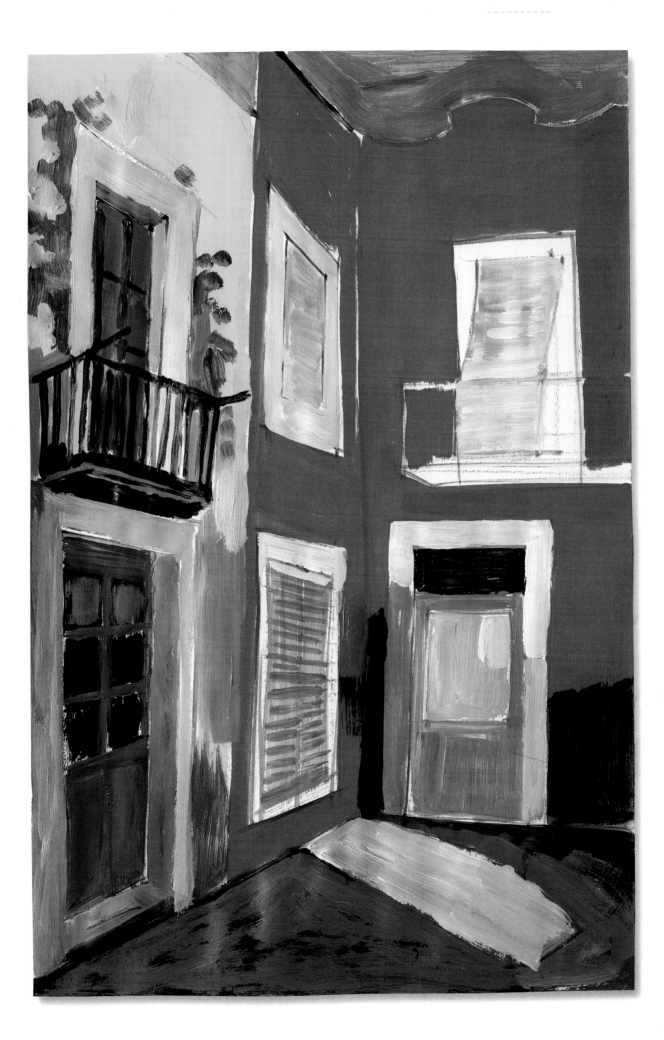

Materials
for Painting
with Acrylics

...ALL PAINTING (AND AS I GET OLDER EVEN MORE SO) IS AN ACCIDENT. I FORESEE IT AND YET I HARDLY EVER CARRY IT OUT AS I FORESEE IT. IT TRANSFORMS ITSELF BY THE ACTUAL PAINT. I DON'T IN FACT KNOW VERY OFTEN WHAT THE PAINT WILL DO...."

Francis Bacon. in Gil Serrano, A.: Bacon. Grandes de la pintura, num. 131, Sedmay, Madrid, 1979, page. 217.

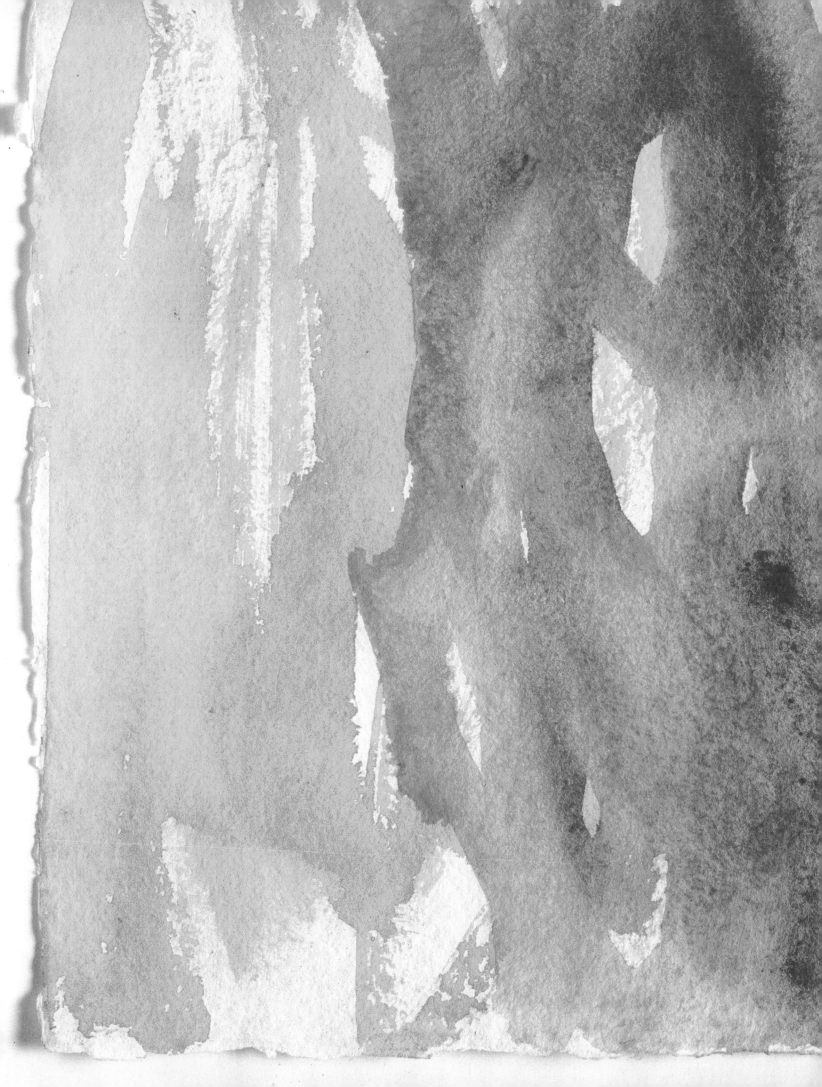

Acrylics:
What Are We

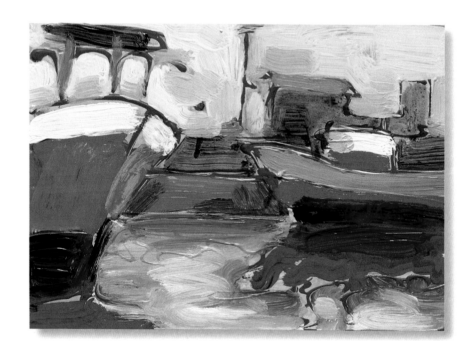

Working With?

Although the materials for painting and the pigments used

in acrylic colors are the same as those in oil paint and watercolors, acrylics have two unique ingredients: synthetic resin, which binds the pigments together, and the mediums, which help modify their consistency. Acrylic, a relatively new medium with a synthetic resin base, has all the advantages of traditional paint and very few of its disadvantages. They have been continually improved and purified since the 1950s, and today represent an important addition to the repertoire of permanent painting media.

What Are Acrylics?

Acrylic paints are a product of the plastics industry, much like the paint emulsions that we use for walls. They use the same pigments that are found in oils and watercolors, but they are diluted in an acrylic agglutinate or binder made of a synthetic resin (based on acrylic acid). The resulting material is water-soluble. It dries quickly, whether it is the matte finish with less acrylic material or the glossy finish with more acrylic.

THE RESIN AGGLUTINATE

The name of this paint is derived from the acrylic resin, the agglutinate that holds the pigment in suspension. It is a synthetic material, consisting of an emulsion of extremely fine resin particles dispersed in water that in large part define the

different characteristics of this medium. As the water evaporates, the resin particles set and form a very compact film of paint where each tiny particle of pigment is covered by the resin. The result is a permanent, flexible, and waterproof layer of paint that will neither yellow nor change over time.

CONSISTENCY

In general, acrylics have a creamy consistency; however, they are also available in liquid form. The creamy acrylics are usually supplied in tubes, just like oil paints. When a project requires a greater amount of paint, it can be acquired in plastic containers of different sizes and shapes, with or without applicators. You only have to add medium to the acrylic paint when you wish to give it more volume, or if you desire a matte or glossy finish. Other than these exceptions, the paint is generally used directly from the tube.

Small glass containers of liquid acrylics are also available for small projects, and are very useful for illustrators.

If you try to open tubes of dried acrylics, you will see the true nature of this plastic material. Upon drying, the paint forms a compact mass of semi-hard plastic.

The acrylic resin, when mixed with a pigment, acts as an agglutinate. Many artists use latex as a substitute binder, because it has many similar characteristics to acrylic.

GOOD QUALITY AND STABILITY

In recent years the quality of acrylic paint has notably improved. They now contain more pigment, the resin agglutinate is more flexible, and there is a very wide range of mediums.

The colors are very stable and very resistant to oxidation, which makes this the medium that presents the least number of problems when it comes to its conservation and the alteration of its original colors with the passage of time. Acrylics are resistant to sunlight and the pigments do not fade.

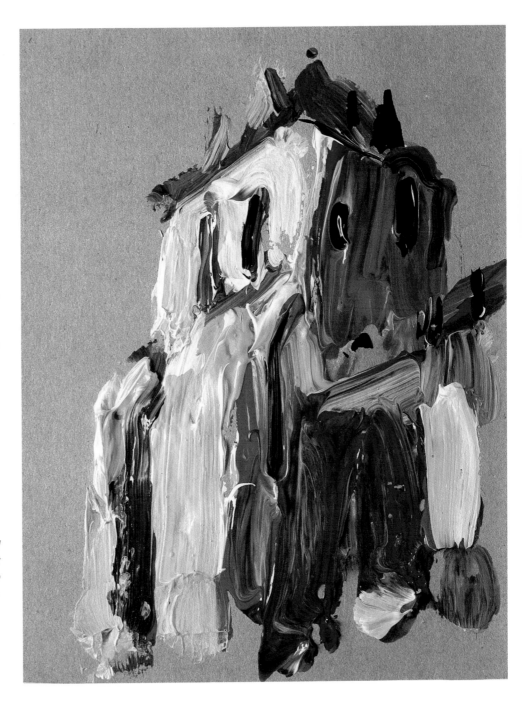

When dry, acrylics are very stable and flexible no matter how thick the paint layer. The colors are bright and do not change over time.

They are characterized by their creamy consistency and the bright, intense colors when dry.

Color Selection

The range of available acrylic colors is not very great. If you desire a wide range of colors you must mix them with white or other pigments.

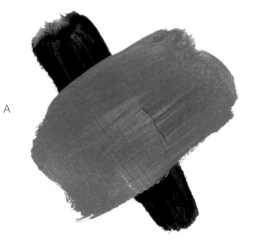

A

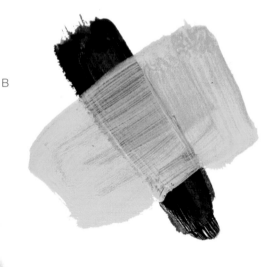

B

We differentiate two types of acrylic paint by their consistency: the opaque ones, which easily cover a layer of darker paint (A), and the transparent ones, which lose their opacity and allow colors underneath to show through when they dry (B).

Although acrylics are sold in a wide variety of ways (they are available in very different containers: plastic jars with screw tops, in tubes, in glass bottles with droppers), the range of available colors is quite limited. However, the number can be increased with the addition of the fluorescent and iridescent paints, especially if our painting style is very modern or contemporary.

A LIMITED COLOR RANGE

The range of acrylic colors is slightly limited compared to that of oil paints or watercolors. This is because some pigments do not mix well with the resin agglutinate, and tend to clump. In many of these cases alternative pigments are used, so that if you compare an oil color chart and one for acrylics you will see that most of the colors and their names vary greatly. Be careful with the manufacturers as well; they can also confuse us. Two different brands of acrylic paint can have two different names for the same color.

Although acrylics are available in jars with large lids, bottles with squirt tops, and in liquid form, tubes continue to be the artist's favorite container.

OPACITY AND TRANSPARENCY

The range of acrylic colors can be divided into two groups: those with a dense composition and those that become somewhat translucent upon drying; in other words, opaque and transparent. The opaque colors will completely cover an underlying color, like a light blue that can cover a dark green. The transparent colors do not completely cover the color that lies beneath; they are able to make blends, but not cover with a single layer. They can only cover another color if several layers of paint are applied. However, the best remedy for this is to add a bit of white to the color to make it more opaque.

DIFFERENT RANGES OF LIGHT

Besides offering the traditional range of colors, acrylics also have varieties that are strictly related to the way in which light is reflected on the component particles. The best-known varieties are the pearlescent and fluorescent colors. The iridescent colors have a pearly sheen that changes according to the way that light hits the painting or the angle from which it is viewed. They are manufactured using mica mixed with titanium. The range of colors that can be created is limited; it is best to buy an iridescent medium and mix it with each color. The fluorescent colors are extremely bright and even loud. They have the additional characteristic of being reactive to ultraviolet or black light.

Pearlescent colors have a very characteristic color that varies according to the position of the viewer in relation to the painting.

The fluorescent colors are an explosion of intense color seen here in the orange lines and areas of green. Its main use is to create visual excitement.

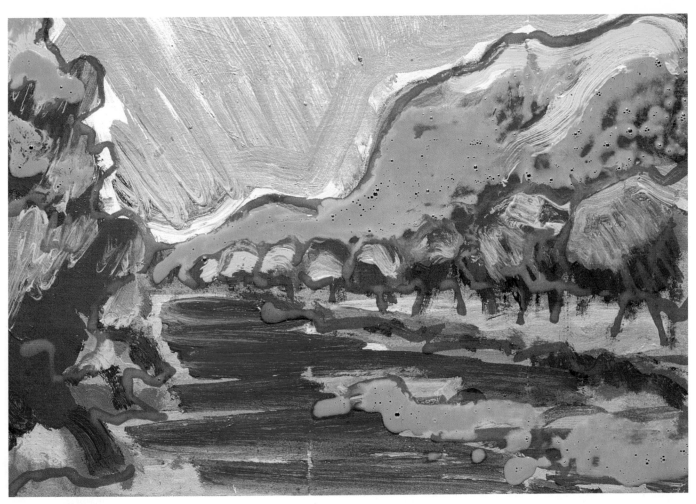

There are a wide range of substances, known as mediums, which can be mixed with paint to modify its fluidity or create particular effects. If you wish to explore all of the creative possibilities of acrylics, you must become familiar with the mediums and discover what they do.

Mediums:
Modifiers of Fluidity

The consistency of acrylics can be adjusted to our needs to create transparent effects, more gloss, and greater density.

THE ADVANTAGES OF MEDIUMS

Normal acrylic paints acquire a semi-gloss finish when they dry. If water is not added to them, their sheen is similar to that of an eggshell. To modify this finish manufacturers produce various acrylic mediums that create different finishes when added to the paint. This means that unlike other kinds of painting media, acrylics can modify the final look of the color according to the preferences and interpretive requirements of the artist. This is without a doubt a great advantage.

GLOSS MEDIUM

This modifier helps dilute the paint, increasing the luminosity of the acrylics and causing the layer of paint to look shinier when dry. Furthermore, it makes the paint more transparent, which turns it into a medium that is very useful for working with glazes. There are two ways to incorporate the gloss medium: mixing the medium with each color before applying it to the support, or applying a fine coat over the paint to give it a glossy finish.

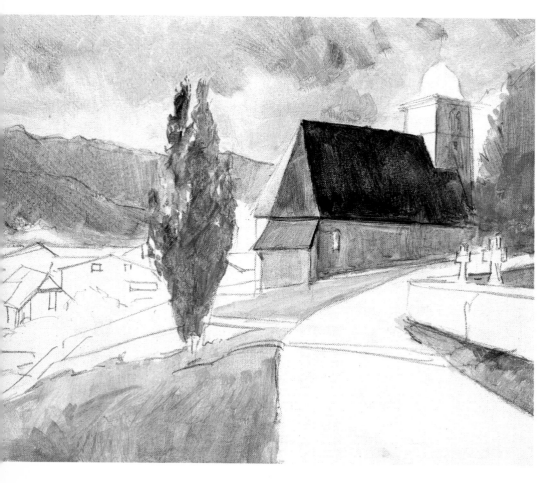

Gloss medium is very useful for making washes and glazing, since it preserves the intensity of the color after it has dried.

Although acrylics are very versatile and can be applied with different consistencies, mediums are able to strengthen these effects even more.

It is not advisable to hurry out and blindly buy a selection of expensive mediums. Some of them undoubtedly can produce dramatic results, but too many special effects can distract attention from the image itself.

MATTE MEDIUM

This medium contains a matte agent consisting of an emulsion of wax or silica. It is used in the same manner as gloss medium, but it is different in that it forms a matte surface that is not reflective when it dries. When it is added to the paint, its fluidity and transparency increases, making it useful for matte glazes. If you wish to create a satin finish, or semi-gloss, you can mix equal parts of matte and gloss mediums.

HOW TO WORK WITH MEDIUMS

Instead of preparing a fluid mixture of paint and water, it is better to use a medium as a thinner so that the paint does not lose its properties and stability. To mix acrylic medium with the paint, the colors are mixed first, and when the desired tone is achieved a small amount of the medium is added with a brush. Mix it until the color is evenly distributed. At this point, a small amount of water may be added. In addition to increasing the gloss of the intensity of the colors, mediums can be added to the paint to increase its drying time, to produce different consistencies and finishes, and for adding texture and filler materials.

1. The correct procedure for adding medium to acrylic paint. First we mix the colors to achieve the desired tone.

2. We add the medium to the color, and mix them uniformly.

3. After several circular motions with the brush the medium is completely integrated with the color. Now we can paint.

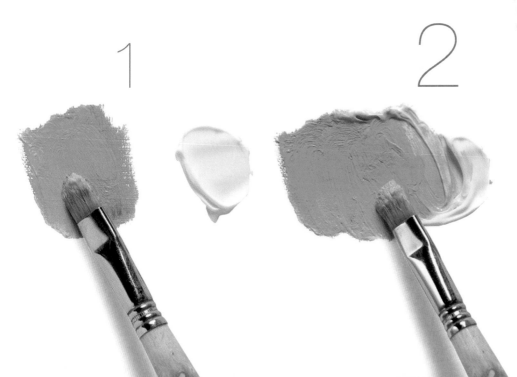

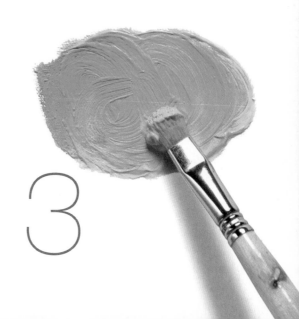

Gels and molding paste can be mixed with paint to give it more viscosity and volume.

GEL

This is a transparent medium that is mixed with the paint to increase its viscosity, the volume and thickness of the paint, which allows it to preserve the marks of the brush after it has dried. By increasing the thickness of the paint you strengthen the effects of textured and impasto brush marks. Gel is used for very heavy impasto work, because in addition to thickness it adds body. You can choose from among light, medium, and thick gels, according to your needs.

MOLDING PASTE

This is a gel to which filler material—normal washed sands or marble dust and granulated products—has been added. Molding paste is very useful for impasto techniques with a spatula or palette knife. You should never attempt to spread them with a paintbrush. They will destroy the most durable of paintbrushes because they are so abrasive; remember that they contain sand. When they are damp they have a milky gray color, and when they dry the gray color turns a bit darker. This must be kept in mind if you mix them with transparent or very light colors.

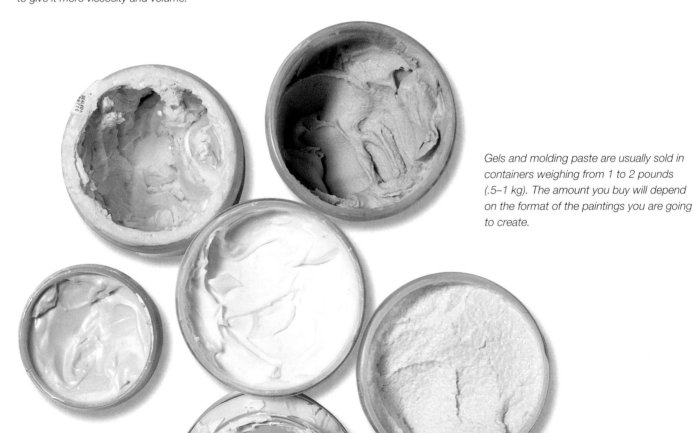

Gels and molding paste are usually sold in containers weighing from 1 to 2 pounds (.5–1 kg). The amount you buy will depend on the format of the paintings you are going to create.

The most common mediums used for increasing the volume of acrylic paint: gesso (A), heavy molding paste (B), gel (C), and light molding paste (D).

A

B

C

D

RETARDER

This is a solution to the main inconvenience of acrylic paint: its rapid drying time. By adding retarder you prolong the drying time of the paint by a few hours, which means that it can be manipulated for a much longer period, especially when using wet on wet techniques, graduated color blending, etc. Retarders are especially useful if you are working with thick paint, that is, when you want to work in impasto, or other mixtures, and move the paint all over the surface of the painting. It is available in liquid form and in gel, and it is mixed in a proportion of approximately one part for every three parts of paint. Excessive retardant causes the paint to stay sticky and unpleasant to the touch.

Different varnishes are sold for use with acrylics, and they should not be mixed with the paint as if they were mediums. They are only used for finishing and are applied when the painting is completed and dry.

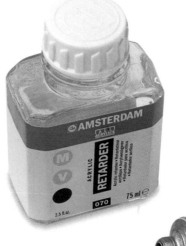

Retarder is transparent, it is available in bottles and tubes, and it is added to the paint to increase its drying time.

The Working Palette

There are two special kinds of palettes for working with acrylics; one is the white plastic palette, which is easily cleaned, and the other is the Stay Wet palette, which can be seen on the following page. If you do not want to complicate things, you can also substitute a plate, a white ceramic tile, or a hard piece of plastic.

PLASTIC PALETTES

Acrylic palettes are usually made of white plastic and are available in many sizes and shapes. They are light and can be transported easily.

If you are working on a small scale or using a watercolor technique with acrylics, a plastic or ceramic watercolor palette, or a china plate may be useful. Acrylic paint dries quickly on the palette, so it must be kept damp by wetting it with a spray bottle of water. If you are not going to use the palette for a while, it should be covered with a piece of plastic wrap.

A palette for acrylics can always be improvised as long as it is smooth; it can be a piece of clear glass, acetate, or polyurethane if you remember to place a sheet of white paper underneath.

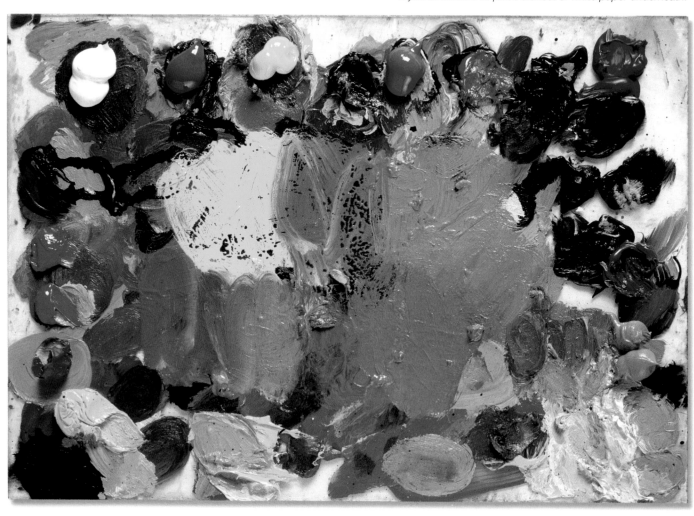

You can recycle an old cologne bottle for spraying water on the palette to keep the paint from drying.

IMPROVISED PALETTES

Stay Wet palettes, and similar palettes of other brands, do not have much room for mixing paint, and many artists prefer to improvise with their own palettes. Any surface can be used as a palette as long as it is not absorbent. A sheet of plastic or a piece of glass can fulfill the same function and they can be of any size. Paper plates can also be used, and they can be disposed of afterwards.

PALETTES FOR OUTDOORS

Stay Wet palettes are very handy for painting outdoors, where the paint tends to dry quickly and become a problem. They maintain the moisture in the paint while the artist is working. It is basically a piece of plastic covered by a blotter paper that has a special membrane. The paint is put directly on the membrane, which absorbs the moisture from the blotter paper and keeps the paint damp. The paint stays moist and malleable while it is being used, and if you replace the plastic cover when you have finished working the paint can last for up to two weeks.

A palette for acrylics can be bought or improvised; below is a porcelain palette with wells, but a simple ceramic tile may also be used. It should be white so you can easily see the colors you are mixing.

Traditional wood palettes are not appropriate for acrylics; the wood fibers absorb the paint and it is very difficult to remove later.

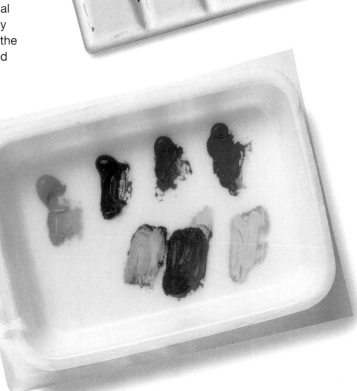

You can make your own "stay wet" palette using a Styrofoam tray and plastic wrap to keep the paint from drying too quickly.

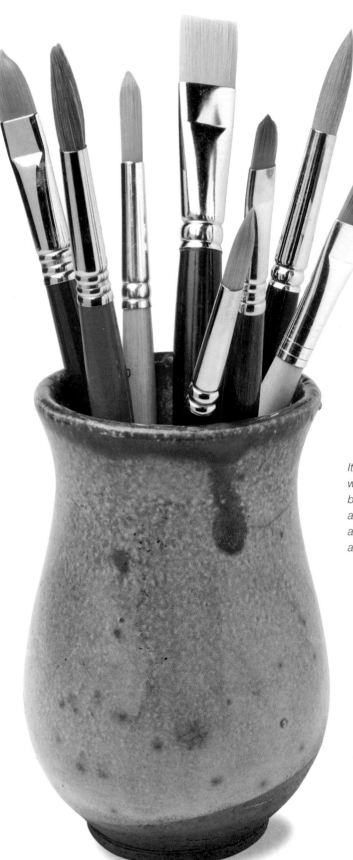

Appropriate
Brushes

There are many kinds of brushes of different sizes, shapes, and quality. Here we recommend the most appropriate ones and offer some basic advice for their care and maintenance.

SYNTHETIC BRUSHES

All brushes with natural hair are appropriate for painting with acrylics, so if you already have oil or watercolor brushes they will work fine. If you wish to purchase new brushes it is worth considering synthetic brushes instead of those with natural bristles. In fact, synthetic brushes are better for painting with acrylics because they are easier to clean and they are designed to withstand the heavy use that is common with acrylics.

It is a good idea to have a wide and varied selection of brushes in different shapes and sizes. Synthetic brushes are highly recommended, and they are easy to clean.

This is how the brushes can end up, with bent bristles, if they are left standing in a container of water for a long period of time. This should be avoided.

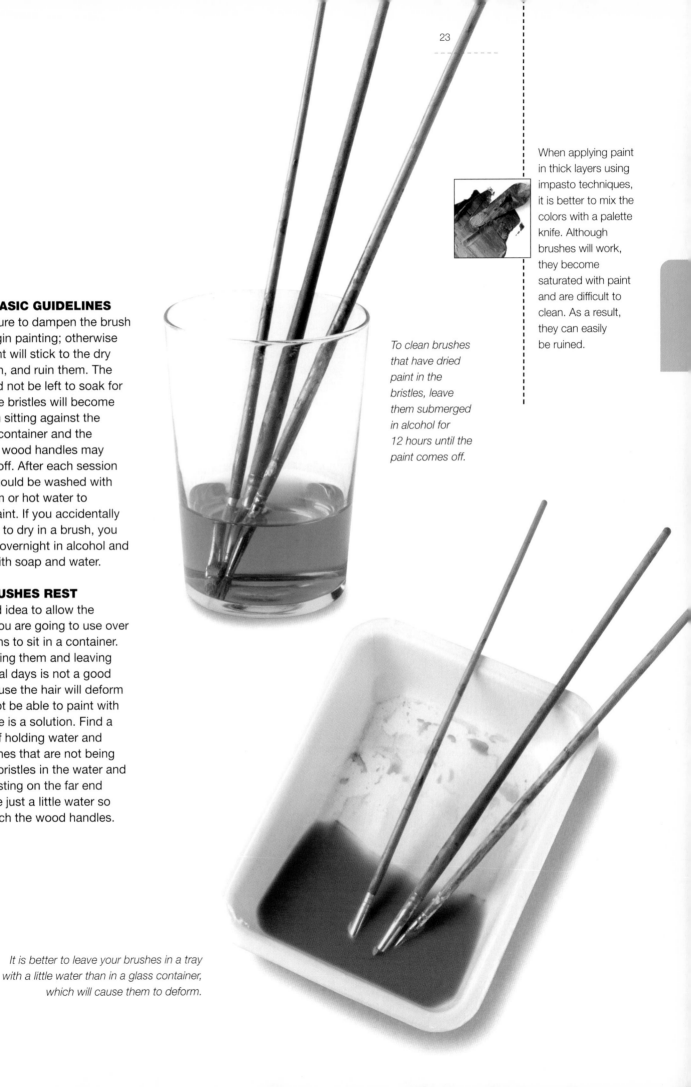

THE FOUR BASIC GUIDELINES

You must be sure to dampen the brush before you begin painting; otherwise the acrylic paint will stick to the dry bristles, harden, and ruin them. The brushes should not be left to soak for a long time; the bristles will become deformed from sitting against the bottom of the container and the lacquer on the wood handles may begin to flake off. After each session the brushes should be washed with soap and warm or hot water to dissolve the paint. If you accidentally allow the paint to dry in a brush, you should soak it overnight in alcohol and later wash it with soap and water.

LET THE BRUSHES REST

It is not a good idea to allow the brushes that you are going to use over several sessions to sit in a container. Avoiding washing them and leaving them for several days is not a good practice, because the hair will deform and you will not be able to paint with them. But there is a solution. Find a tray capable of holding water and leave the brushes that are not being used with the bristles in the water and the handles resting on the far end of the tray. Use just a little water so it does not reach the wood handles.

When applying paint in thick layers using impasto techniques, it is better to mix the colors with a palette knife. Although brushes will work, they become saturated with paint and are difficult to clean. As a result, they can easily be ruined.

To clean brushes that have dried paint in the bristles, leave them submerged in alcohol for 12 hours until the paint comes off.

It is better to leave your brushes in a tray with a little water than in a glass container, which will cause them to deform.

The attraction of acrylics is that they can be used to paint on any surface as long as it is not oily since they have a water base that is incompatible with oil. In theory, you could use anything that you want as a painting support: a canvas, a wood board, cardboard, even a piece of plastic or metal.

Painting Supports

THE MOST COMMON SUPPORTS

Acrylic paints will adapt to a great number of surfaces: canvas, wood, fiberboard, cardboard, and paper. In principle, they can be applied without any base or preparation, although it is usual to use an acrylic product or gesso as a primer. Let's take a quick look at the most common supports.

Paper. If you wish to use very wet, diluted paint, watercolor paper is the best choice. For a medium consistency paint, good quality cardboard or mat board is an excellent and inexpensive support.

Canvas. All kinds are adequate, from burlap to fine linen. They give very good results with acrylic paint. Normally, they are sold already primed, and there is no need to apply a layer of gesso; however, if a burlap material has a very open weave it is a good idea to prime it with an acrylic medium.

Cardboard. Acrylics adhere to most cardboard, poster board, or durable paper, with or without a primer. Only thick and rigid cardboards should be primed with gesso because thinner cardboards tend to warp too much.

Wood. Wood boards are excellent supports for acrylics. Natural planks, plywood, and fiberboard can all be used. A base of a layer of paint or gesso will prepare the surface of the board for painting. If you desire a smooth finish, it is best to sand the surface before painting.

A

B

C

D

The way to see if acrylics can be used with any surface is to simply paint on four samples: in this case plastic (A), watercolor paper (B), cardboard (C), and mat board (D).

Since they are very adhesive acrylics can be painted on practically any surface, whether primed or not.

Metal. Metals have very smooth, non-absorbent surfaces without texture to help retain the paint. Acrylics are a good adhesive and work quite well on this type of surface, especially on zinc and copper.

Walls. Acrylics are excellent for interior murals painted on plaster, cement, or stone because it dries flat and uniformly. These paintings also tend to resist the effect of acids and humidity.

Wood is usually primed with gesso before painting, because it can absorb too much of the water contained in the paint and cause the brushstrokes to be too thick.

Acrylics do not adhere well to waxy, greasy, and oily surfaces. If you try to paint over an oil painting that has dried, something like this will happen.

INAPPROPRIATE SURFACES

We know that acrylics can be used on a wide range of supports; however, they will not adhere to a surface that contains oil or wax. Synthetic resins, which are suspended in water, will not grab onto an oily base. This eliminates all canvases and boards that already have a layer of oil paint or that have been prepared for painting with oils. Consequently, when buying canvas supports you must make sure that what you are buying has an acrylic primer and not an oil base.

Exploring Acrylics:

Pros and Cons

In the same way that the introduction and popularization

of oil painting opened up a new field of possibilities nearly five centuries ago, the distinct nature of acrylics has today opened the doors to exploring new techniques, with the additional advantage that the new medium is chemically more sure and stable. In the beginning, when the first acrylic paints appeared on the market, the lack of knowledge and experience led many artists to use this paint in the same way as already existing ones, inevitably establishing comparisons with oil and watercolors. However, after several decades of use, it has been proven that acrylic colors posses their own characteristics, and that it was a waste of time to imitate other techniques with them. Acrylics have advantages and disadvantages, and it is the painter's job to decide if he or she can make good use of them despite the limitations.

Paint Quality

The selection of colors is quite personal. However, the beginner should start with a limited palette to learn the potential mixtures that a few basic colors are capable of creating, before moving on to discover less common colors and find new favorites.

COLORS AND BRANDS

Some companies sell their paint for much less than the rest, but often times those paints are less reliable and permanent. The best known brands like Rowney, Winsor & Newton, Liquitex, Titan, and Aquatec offer a wide range of colors. There are subtle differences between them, just as there are between oil paints, and the same color may have different names depending on the brand. The manufacturers guarantee compatibility among their own range of acrylics, while pointing out that their materials are not necessarily compatible with those of other brands.

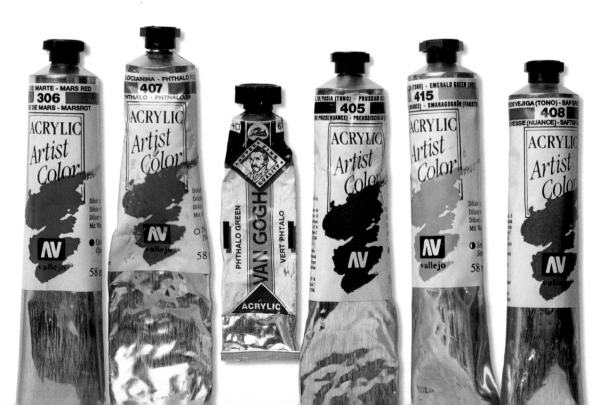

Many pigments do not mix well with the acrylic binder; therefore many colors are labeled "tone"; that is, they correspond to the approximate tone of that color, although the original pigment is not used.

ALTERNATIVE PAINTS

Acrylics are manufactured in almost the same ranges of colors as oils and watercolors with a few exceptions. Thus, we find the traditional yellow ochre, raw umber, Venetian red, cobalt blue, and ultramarine. Some popular colors, like emerald green and sanguine red, do not mix well with the acrylic resin, so alternative pigments are manufactured specifically for making acrylics, like naphthol red, phthalo green, indanthrene blue, and dioxazine violet. An artist using acrylics for the first time should get advice and experiment to discover the colors that are most appropriate for him or her.

MAINTAINING THE COLORS

Choosing colors well is important, but so is maintaining them. This is why, at the end of a session, it is best to make the effort to clean all the lids and spouts, as well as the necks of the tubes with a damp rag before putting the tops on them. If you do not do this, the paint will harden and will not allow the top of the container to screw on tightly, which will make it more difficult to open the tubes later and also cause the paint inside to dry out. Be especially careful about closing the tops of paint that is sold in glass or plastic containers.

Some brands of acrylics specialize in selling more liquid paint in plastic bottles. They are very inexpensive and are available in different sizes.

It is a good idea to check the density of the paint, since this often varies considerably from one brand to another.

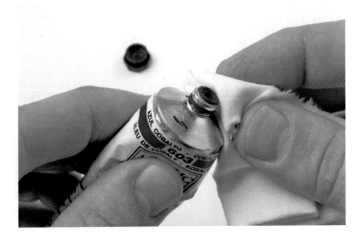

It is important to carefully clean the threads of the tubes with a damp rag; this way we can be sure that they will close tightly and the paint will not dry.

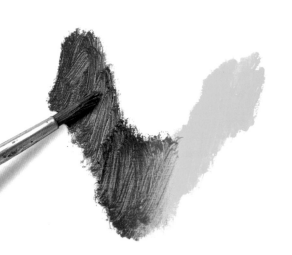

It is advisable to practice mixing the primary colors (blue, yellow, and red) to create the secondaries (green, orange, violet).

Mixing Colors

All artists require a basic knowledge of color, and the only efficient way to learn to mix colors is by experimenting and trial and error. Following, we offer some advice about the basic colors you should buy and how to create the first mixtures.

WHAT COLORS SHOULD WE BEGIN WITH?

It is clear that a palette with many colors is not necessarily an advantage for the beginner, no matter which medium is being used. Professionals usually work with a range of about 25 colors; however, with 10 to 15 we can achieve an endless variety of possibilities. Here are colors you should buy that will give you a minimum guarantee of success when you start painting: white, cadmium yellow, orange, yellow ochre, raw sienna, Venetian red, cadmium red, violet, cerulean blue, ultramarine blue, sap green, emerald green, raw umber, and black.

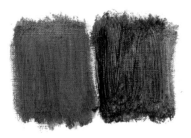

When creating oranges and violets by mixing, the resulting colors are somewhat darker than those you can buy in the store. Compare the colors from the tube (left) with the mixtures (right).

A B C D E F G

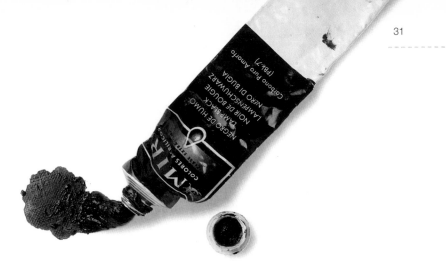

ORANGES, GREENS, AND VIOLETS

You know that the color orange can be made by mixing yellow and red, blue and yellow make green, and red and blue make violet. But if you try to mix them with acrylics the results will be disappointing, as you will get a dull orange, a dirty green, and a muddy violet. Because of this it is a good idea to have a tube of orange in reserve, another of violet, and a couple of greens. We can always resort to them when we really need a bright and intense color.

THE DEBATE ABOUT BLACK

Including black in the list of basic colors can be debated. Many artists consider this color unnecessary, since it can be created by mixing other colors, like ultramarine blue, Venetian red, and a dark green. However, a black created by mixing these colors is more interesting and harmonizes better with the rest of the painting than black from a tube. Black is usually avoided, although many beginners make the mistake of using it to darken colors, which often alters the strength and character of some of the pigments. For example, red and black make an earth color, and black and yellow make green. Black is not usually used for mixtures; it is only used when there is a very good reason, like representing a night scene.

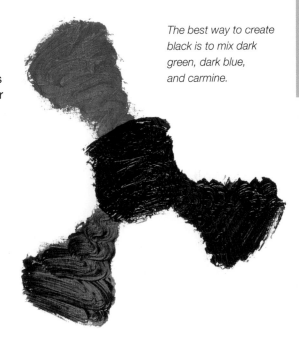

The best way to create black is to mix dark green, dark blue, and carmine.

Black should not be used to darken colors, since it alters them too much, turning red and yellow into muddy, brown colors.

The complete list of suggested colors for painting with acrylics: titanium white (A), cadmium yellow (B), orange (C), yellow ochre (D), raw sienna (E), red madder (F), cadmium red (G), permanent violet (H), cerulean blue (I), cobalt blue (J), permanent green (K), phthalo green (L), raw umber (M), and black (N).

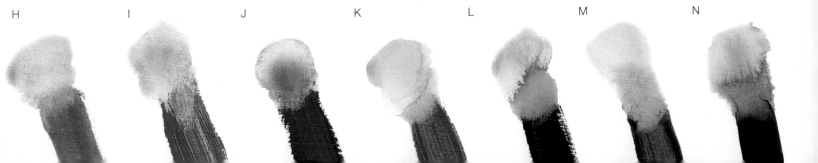

H I J K L M N

Among acrylic paints the intensity and opacity of the colors varies. You should learn to distinguish the chromatic characteristics of each color and take that into consideration when you create new colors by mixing.

STRONG COLORS AND WEAK COLORS

Some pigments have a stronger and more intense color than others, and therefore are more useful for mixing. If you work with very strong pigments, you should use a very small quantity to tint a mixture, because if we use too much the resulting color could be too strong. With a little practice mixing colors will soon make you familiar with the tinting power of each pigment. Normally, this tinting power is closely related to the opacity of the color. The more opaque the color, the greater its tinting power; on the contrary, the more transparent the color, the more you will need in the mixture. Try a red (strong color) and a yellow (weak color); to make orange, we barely need a drop of red added to a generous amount of yellow.

ADDING WHITE OR WATER

After a color is mixed, you must consider whether to lighten the color in one way or another, depending on the technique you are using. For example, if you paint with diluted paint, using watercolor techniques, the colors should be lightened using water. For opaque treatments, the colors are lightened using white. But this should be done with care, since white alters the character of some colors. If you have the opportunity to lighten a color with other lighter paints from the same range you should do it this way to avoid making the resulting color too chalky.

To evaluate the opacity and transparency of each color, we have painted a black line. Then a brushstroke of thick paint was applied over it. After they dry we have a good idea of how some colors are more transparent than others.

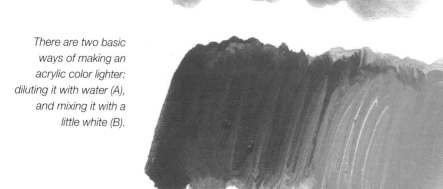

A

B

There are two basic ways of making an acrylic color lighter: diluting it with water (A), and mixing it with a little white (B).

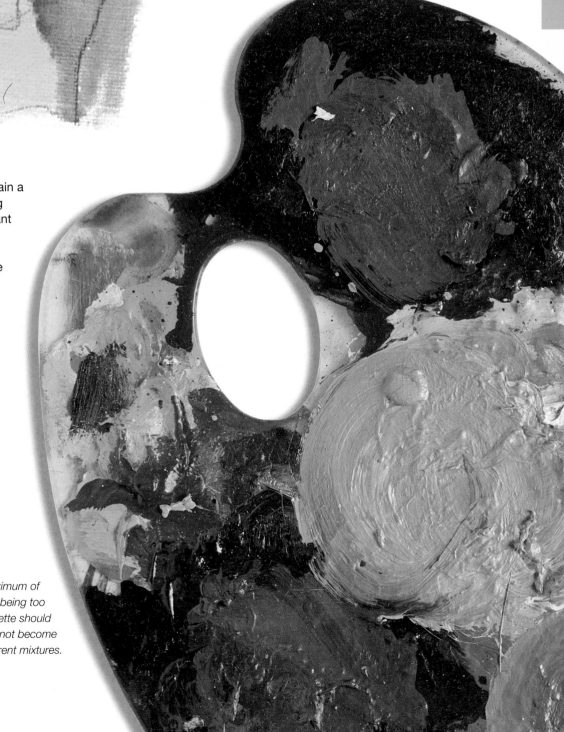

When working with washes the paint should be very diluted; otherwise it will ruin the effect of the drawing. Choose transparent pigments.

DO NOT MIX TOO MUCH

The only way to discover how to obtain a color is to mix it yourself by choosing colors from your palette. It is important to know how to mix and to find the colors of the subject. After a while, inevitably, the color mixtures become confused on the palette; that is, they tend to overlap, especially in the last phases of the work. This is dangerous and can cause you to mix your colors too much, and it is easy to end up with a totally gray palette and muddy paint. Therefore, do not mix the colors too much, three colors at the most, and then clean the palette once there is no space between the mixtures.

Mixtures should be limited to a maximum of three colors to keep the results from being too muddy. For the same reason, the palette should be cleaned once in a while so it will not become overloaded with different mixtures.

Some Applications
to Try

The results of many other classic media can be imitated and even improved upon with acrylic paints, since it has the same transparencies as watercolors, the same amount of opacity as gouache and tempera, and the thick dense consistency of oils. But to better understand its capabilities, you should try the colors to observe how they react and what uses they can be put to.

WORKING WITH LITTLE PAINT

Since acrylics dry quickly, it is better to squeeze out less paint than is needed, especially if you intend to experiment with color. You can always go back for more paint when you need it and the addition of clean paint will refresh the colors on the palette and keep the paint soft and manageable. Artists inevitably use a lot of white and they probably use at least twice as much white as any other color.

If you are going to paint with diluted acrylics you should put just a little paint in the palette to avoid allowing it to dry before it gets used.

The best way to convince yourself of the versatility of acrylics is to paint the same subject while varying the consistency of the paint. The first example was done with very diluted paint.

In the second example the paint is less diluted and creamier. The colors are brighter and the brushstrokes more opaque.

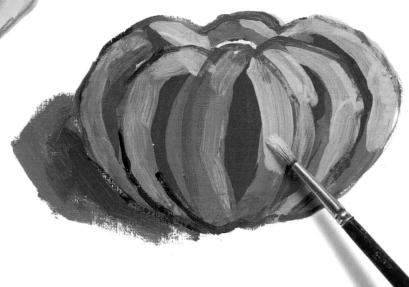

TESTING ITS VERSATILITY

Select a simple object as a subject and try to reproduce it with just a few brushstrokes. Draw it several times to paint it with different consistencies of paint. In the first version, we cover it with very diluted washes; in the second, with flat and opaque brushstrokes; in the third, with thick creamy brushstrokes; and in the last, with impasto applied with a spatula. This simple exercise will allow you to test the adaptability of the paint in each circumstance.

TESTING ITS DRYING TIME

After doing this simple experiment you can draw two conclusions. The great advantage of acrylics, when working with glazes, is its fast drying time. This allows you to overlap layers of paint without waiting for the previous layer to dry. But this apparent advantage becomes a drawback when the paint that we apply is creamy or thick, since it becomes difficult to move it around the surface and to mix it.

The subject displays greater solidity with thicker paint; the body seems more compact and it is possible to distinguish the brush marks.

The best way to apply heavy acrylics is with a spatula. Here, the paint shows a pronounced texture and the mixing of the colors is less careful but more expressive.

1

Acrylic paint is the medium that offers the most when working with textures. It is very easy to add materials to it, which can give the paint wrinkled, pasty, or granulated textures, depending on the material added to it. This opens the doors to special effects and to painting with relief, offering limitless options to the artist who wishes to create paintings with very modern and contemporary finishes.

Creating Textures

WORKING IN RELIEF

Acrylics can be mixed with sand, sawdust, straw, or marble dust to create textures; however, these materials do not mix with the paint that easily. First you must prepare a modeling paste. To make this, a little latex is poured in a bowl and then the texture material is added. It is mixed well to allow the latex glue to permeate all the material. Now the substance is ready to be mixed with acrylic paint.

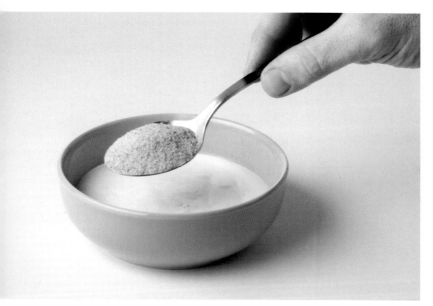

2

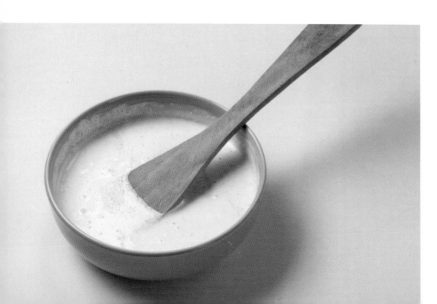

3

1. You can buy the modeling paste in an art supply store or make it yourself. For the latter you need a bowl and white glue or latex.

2. Pour a generous amount of latex in the bowl and add the material, which can be sand or marble dust.

3. Mix the two ingredients to create a thick consistent paste. This can now be added to the paint to give it volume.

Modeling paste can be directly mixed with the acrylic paint, but to apply it we need a spatula because it is too dense for the use of brushes.

Modeling paste is a strong adhesive, and objects can even be pressed into it while the paint is still wet.

MODELING PASTE

The acrylic mediums like modeling paste, gel, and other thickening substances can be purchased in art supply stores; there is no need to make them. When you mix them with paint you must keep two things in mind. First, you should never put more than 50% medium in any mixture; otherwise the color will lose strength. And second, you must be careful with mediums mixed with marble dust or sand because they tend to have a grayish color when they dry; this means that they can also turn acrylic paint colors gray. You should remember this if you do not want any surprises.

HOW TO APPLY THE PASTE

Modeling paste can be mixed with the paint, but the resulting mass is so thick that it is not easy to handle. This makes it necessary to work with a spatula. The paste is applied directly to the support to create the relief; after it dries it can be sanded a little to remove areas that are too high. The paste should be applied in ¼ inch (6 mm) layers at most, allowing each layer to dry before adding the next one. If the layers are too thick the outside will dry faster than the inside and possibly cause the surface to crack.

The modeling paste adds a very characteristic relief to the painting, which does not show much detail.

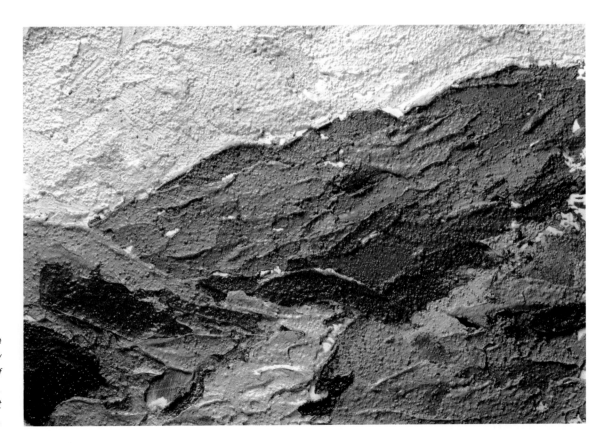

Tech-niques

with Acrylics

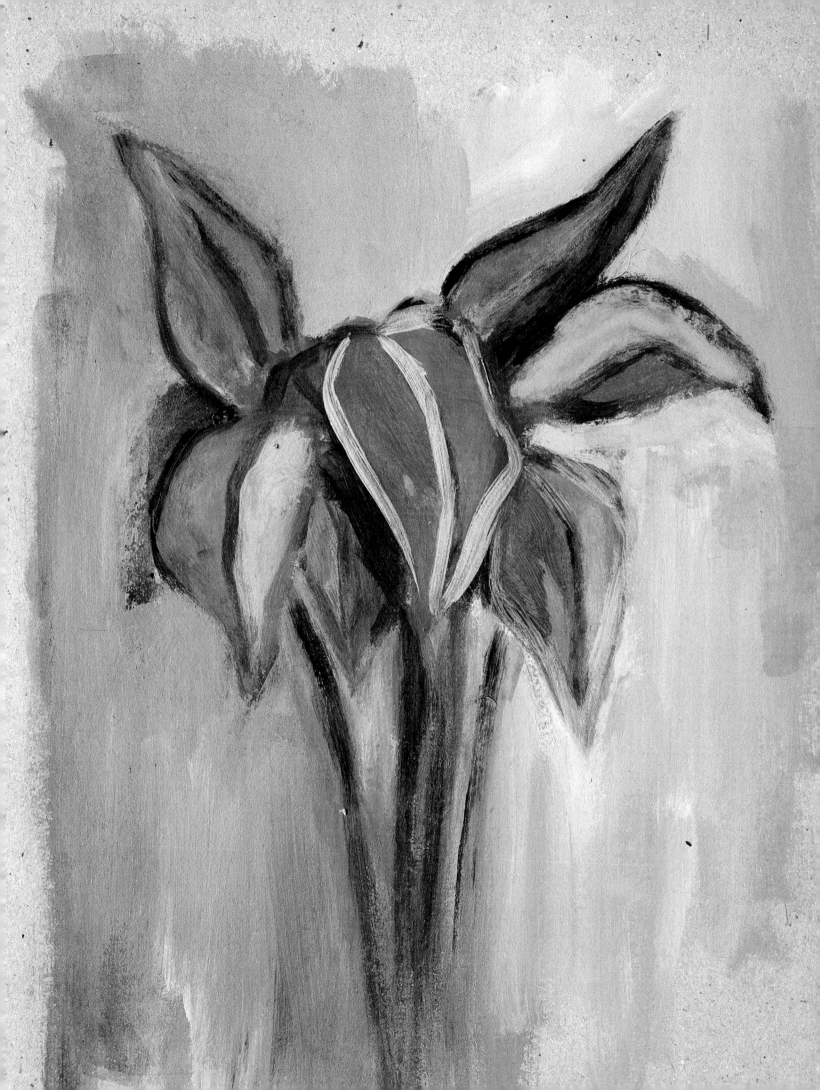

Acrylic

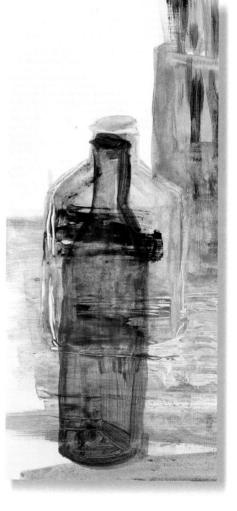

Washes:
Glazing and Transparencies

Acrylics can be used diluted with water, overlaying several washes of transparent color. This renders effects similar to those of watercolors, but the finish is matte and the colors are not quite as bright. The advantage with respect to watercolors is that when it dries the paint is no longer soluble. No matter how much we work it with a brush the underlying colors are permanent; they cannot be diluted or altered. This means that any color changes to a wash must be made while it is wet because later it will not be possible.

Starting the Painting:
Using Base Colors

A pencil line drawing is the most common approach, especially if you will be working with transparent layers of paint.

Drawing before painting is not a hard and fast rule. Some artists barely draw a few pencil lines or make some marks with a brush to establish the main reference points of the composition. Then they choose the most appropriate manner of preparing the support and making the first applications of paint.

LINE DRAWING
The most popular way of beginning a painting is to make a light pencil drawing on the surface before applying the paint. It is not necessary to make a very detailed drawing, just a few linear shapes or outlines are enough. Do not waste time with details; most of them will be covered by the first layers of paint. Also do not make the mistake of drawing with charcoal, chalk, or

sanguine crayon, since these materials create a lot of dust that will muddy and affect the purity of the acrylic colors, especially the light ones.

PAINTING WITH DILUTED COLORS
The first painting can be done over the pencil drawing or even on a blank white canvas. It is not a matter of thinking in shapes and outlines, but in colors. Apply areas of color diluted with water, which will dry quickly. In this aspect acrylics are very similar to watercolors. One of their main advantages is the ability to become transparent when they are mixed with water or acrylic medium.

You should avoid using charcoal since the black powder will come off and mix with the colors making them gray and dirty.

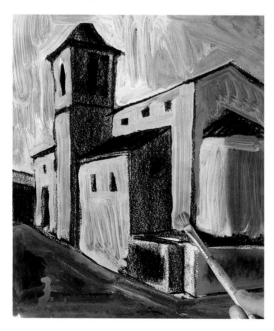

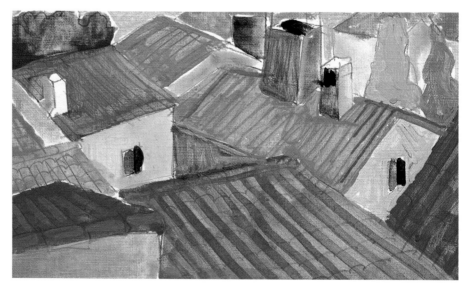

The first areas of color should be somewhat flat and diluted with water; they will be the base for future applications of paint.

MONOCHROME UNDERPAINTING

A monochrome underpainting of the work, usually in gray, brown, or blue, helps you to analyze the main values and tonal relationships. Preliminary painting in black, white, and grays give very good results in paintings that have strong contrasts between light and shadows or a strong tonal structure. The subject is constructed with a monochrome color that is later painted over with new colors that do not completely cover the initial painting. It makes no sense to create a monochrome underpainting if it does not form part of the final image.

SPREADING A BASE COLOR

The canvases and canvas boards sold for use with acrylics are usually white, but sometimes it is helpful to apply a background before starting to paint. Tinting the background is easily done: apply diluted acrylic to the entire surface and in a few minutes it is dry. A neutral color like gray, blue, or ochre is normally chosen. Some prefer brighter and more saturated colors, which later requires painting with more opaque paint.

If you paint often with acrylics it is a good idea to have several papers and supports prepared with various background colors.

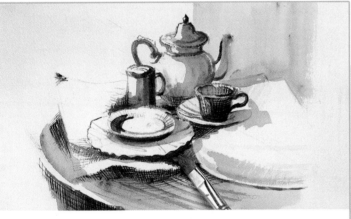

1. A good way to lay out the painting is with monochrome colors; in this case the most useful colors are blues, browns, and grays.

2. After the monochrome underpainting has allowed you to indicate the placement of lights and shadows, the new colors can be added.

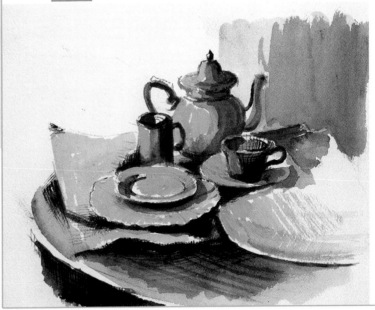

Working
with Line and Color

One of the advantages of acrylic paint is that it can be used for making line drawings, as a preliminary design sketch or as part of a finished work. This, combined with dense areas of color, can give your paintings great expressiveness, especially if you are working with bright colors.

SKETCHES, DRAWINGS, AND COLOR

It is a good idea to make a series of quick sketches to help visualize the final composition before starting the painting. They can take the form of drawings or small color studies. Some artists make both, first making many small drawings and then selecting the best ones and adding color. There are no rules for applying the lines and colors. Some people begin by sketching the subject with lines and finish it with a few strokes of color. There is also the opposite approach, constructing the composition with a lot of color and then outlining the objects to better reveal their presence. Experiment and adopt the most comfortable approach.

An alternative to pencil drawing is drawing with the brush, especially if the background is a color. Colors that contrast strongly with the background color should be used.

Before starting big projects it is good to prepare sketches, making small notes using color and lines. Try to be completely free and bold with the color.

If you decide to draw lines over a sketch made with areas of color, you should make an effort to exaggerate the curves of the outlines of the objects to make the line more graceful and rhythmic.

Typically lines are applied over the areas of color to indicate shapes and outlines, but we can reverse the approach.

DRAWING WITH THE BRUSH

An alternative to pencil drawing is to begin by painting the model with a brush. (If you are not very good at drawing it is a good idea to avoid this approach until your drawing skills improve.) Just use a color that contrasts with the background and note the forms and outlines with a fine, round brush. Then, you can deliberately leave the colored drawing in the final painting, as a graphic element that adds to the mix of colors.

DEPICTING THE WHOLE WHILE AVOIDING THE DETAILS

The main rule of acrylics is to first sketch the most important tone and color areas, then work the entire composition simultaneously without losing sight of the relationships among the various shapes and colors. Working on parts of the painting until the end, with too much detail, is not usually a good idea, because there is a risk that the composition will fall apart.

1. Analyze these two images. First we painted with areas of color, indicating the outlines of the objects through contrast.

2. Then lines are used to define them. The lines add greater rhythm to the composition and increase the visual interest of the objects.

After making some color washes with acrylics, you will see that they flow easily and that they are similar to watercolors. However, while watercolors fade over time—especially if they are exposed to light—most acrylics maintain their strength after they dry.

Let the Water Flow!

LUMINOUS COLORS

Acrylic paint that is diluted in a lot of water or medium will create delicate washes and glazes that will allow the white surface of the paper or the canvas to show through, increasing the luminosity of the colors. When applying a wash, it helps to first dilute the paint in a lot of water and then to paint the area in question, allowing the water to flow on the canvas, directing it with the tip of the brush so that it will cover the areas that we are concerned with.

ADDING MEDIUM TO THE WASH

Controlling washes so that the color is spread evenly can be a problem with acrylics, especially if you are working on paper. This problem can be resolved by adding a glazing or fluid medium, or a little matte or gloss medium. This will give the paint just the right volume so that it will spread with better fluidity on the paper or canvas. The brushstrokes will keep their shape better with a medium and water than with water alone, and they will also be easier to control.

MIXING WASHES

Colors should rarely be mixed on the palette. When working with acrylics the mixing can be done directly on the paper, preferably watercolor paper. It is a common technique in landscape painting because it allows you to determine the subject in a short period of time, while working directly in front of the real subject. The painting begins at the top and different colors and tones are added without waiting for the washes to dry. The result is a very atmospheric painting rich in tones. Let's look at the following example.

We begin the painting at the top of the paper with violet tones, to which we add small strokes of ochre.

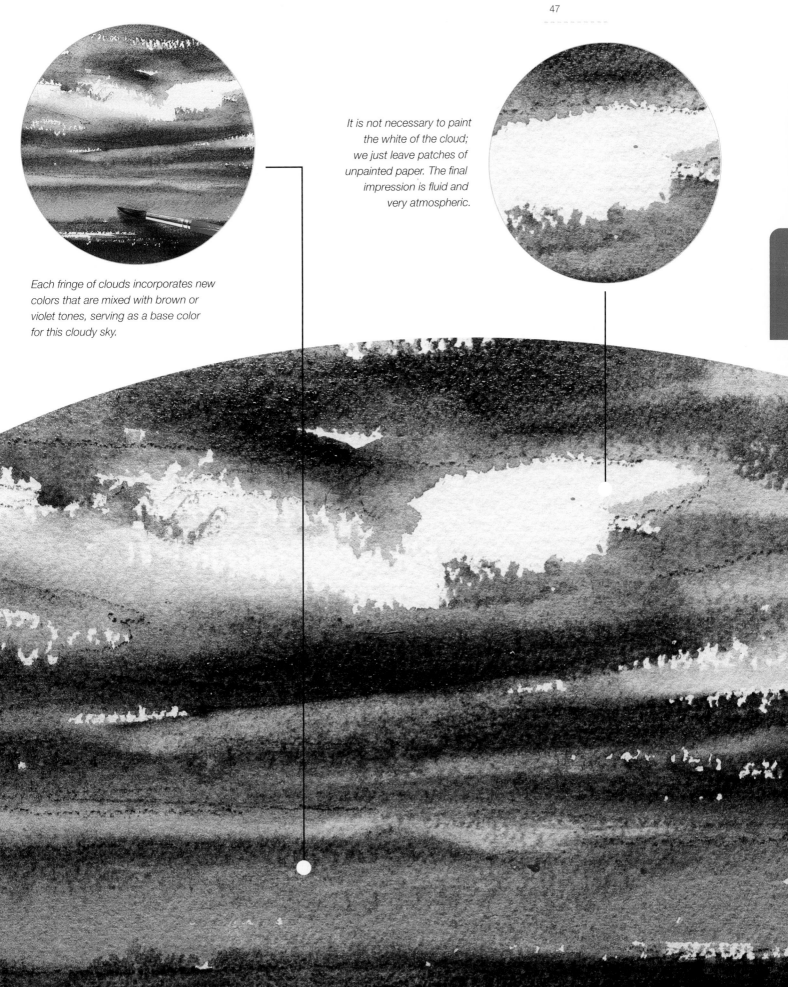

It is not necessary to paint the white of the cloud; we just leave patches of unpainted paper. The final impression is fluid and very atmospheric.

Each fringe of clouds incorporates new colors that are mixed with brown or violet tones, serving as a base color for this cloudy sky.

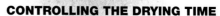

Painting Lines
on a Wet Support

If you dampen the paper first, brushstrokes applied to it will run and create interesting gradated effects. The lines break up into a multitude of streaks that invade the white areas of the paper, creating an atmospheric effect in the painting.

WET ON WET

This describes the technique of applying acrylic paint on paper previously dampened with water or paint. The water causes the paint to expand on the colored surface in an uncontrolled manner. The effect is partially random, but you can control the direction that the paint flows and its extension if you pay attention to the drying time of the paper and the angle of the support.

CONTROLLING THE DRYING TIME

Before painting on paper it is a good idea to test its absorbency. This is done by taking three small cutouts of the paper and wetting them with a brush full of water. The surface should be completely soaked. Immediately draw two blue lines with thick undiluted paint. The color expands rapidly, forming gradations and breaking the sharpness of its edges. Wait two minutes to paint the second paper, and then make two more blue lines. More water has been absorbed; consequently the lines are more solid although the edges are still quite blended and blurry. Part of the color flows into the wet areas of the paper. After five minutes much of the water in the paper has evaporated and the blue lines only show slight alterations in the sharpness of the edges.

It is necessary to conduct drying tests to learn how to better control the flow of the paint. Just wet all the paper that you are going to use at the same time and apply two brushstrokes about every two minutes. As the water in the paper evaporates, the paint spreads less.

A BIRD ON WET PAPER

After testing the drying times of the paper, paint a bird. After the pencil sketch, dampen the paper with a brush. Another brush is charged with acrylic and the wet surface is lightly brushed to deposit the yellow color. The blue paint is added to the wings and tail with the same brush by lightly caressing each area with the tip of the brush. If the paint is not brushed a lot the blue and yellow will not mix too much and become muddied, but will stay in place on the paper, which is left to dry. The last brushstrokes that define the head and shape some of the feathers are applied when the paper is dry.

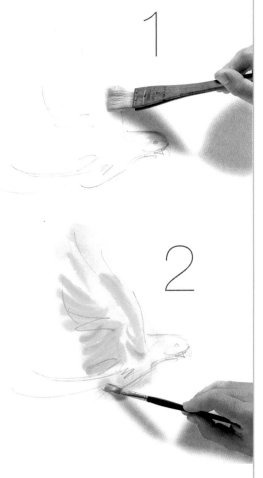

Colors mixed using the wet on wet technique usually maintain their intensity as long as they are not manipulated too much.

1. After making the pencil sketch the paper is dampened with a brush saturated with water.

2. Yellow is applied with a fine watercolor brush. The paint will expand uncontrolled on the wet surface of the paper.

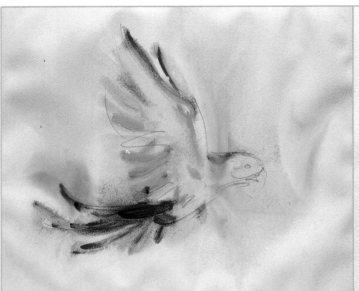

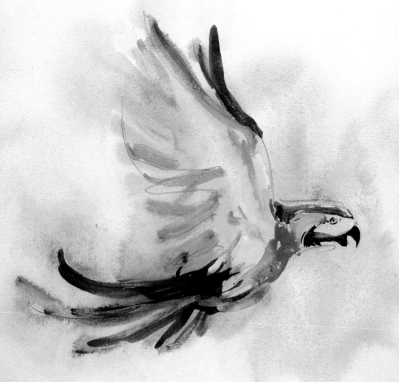

3. After the yellow, new brushstrokes of blue are added. This process is carried out without pausing so that the paper does not dry.

4. The final details of the drawing, more concrete and precise, are made after the paper is dry. Contrast is created between the vaporous and the linear brushstrokes.

Studying Glazes

Glazes are transparent layers of paint that are applied one over the other to create subtle mixes of color. If they are painted on a white surface they show the luminosity of the paper, revealing one of the more attractive benefits of the medium. Superimposed acrylic washes are used to create color mixes with a translucent quality, like sheets of colored glass.

CONSISTENCY OF GLAZES

Glazes can be made with paint diluted with water alone, but the colors will be more luminous and transparent if we use a mixture of water and gloss or matte medium. The successive layers do not have to be of the same consistency. The thickness of the glazes can be altered by reducing the amount of water and increasing the amount of medium. This way the paint will be transparent and creamy at the same time. If the glazes are made with only water they will form a surface of lifeless matte colors; the paint will definitely lose its vigor.

MIXING COLORS BY OVERLAYING

When working with opaque colors, the mixing of paint is done on the palette. When working with glazes, these mixtures can also be made directly on the support, overlaying one color over another to obtain a new color. Superimposing two transparent washes of different pure colors can create a third color that is deeper than if it had been mixed on the palette. Let's try it. Spread a yellow glaze over another already dry one of light blue. The result is a green color, a much richer and more natural green that is better integrated in the painting than a green that has just come out of a tube or that was mixed on the palette.

FROM LIGHT TO DARK

When painting with acrylics you work from light to dark, that is, you begin with the lightest colors and washes and increase the intensity as the exercise progresses. However, acrylics enjoy an advantage; if an area becomes too dark we can return to the light colors or white to apply light glazes over dark ones. This should not become a habit, or you will waste a lot of time making pointless corrections.

Mixing colors with glazes is done by overlaying them. Each addition of color modifies those that are underneath.

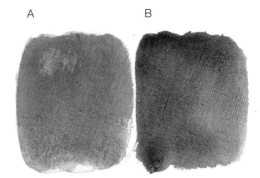

A B

Notice the difference between a green created with glazes, with a more natural tone (A), and one directly from the tube, more saturated and synthetic looking (B).

There is a mistaken idea that the glazing technique allows overlaying as many washes as you want. This is not true, because the colors can become very muddy. We should limit the number to two or three layers.

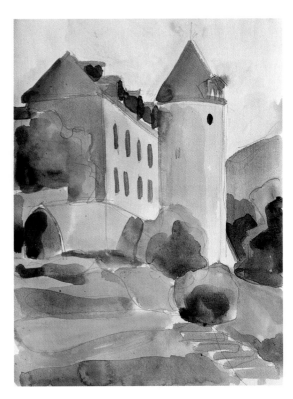

2

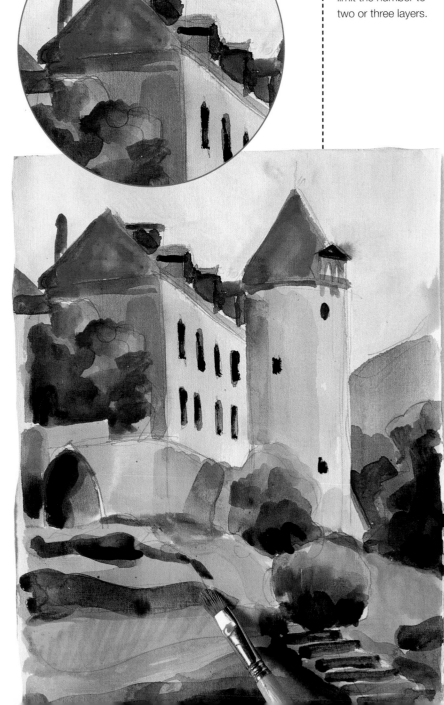

1

1. Glazing begins with a general color layout created with transparent washes.

2. Apply new washes over the previous ones to adjust the colors and add a greater variety of tones in each area.

3. As new washes are added to the previous ones, the tones become richer and the areas of light and shadow are easier to distinguish.

3

Monochrome Techniques
with Glazes

The first attempts at glazing should be monochrome, to better understand the tonal relationships.

The best way to learn the glazing technique is through brief exercises done using one color; this way you can see how the successive washes create depth and darken the tone, without having to face the difficulties involved with mixing colors.

THE COLORS THAT SHOULD BE USED
Working with a single color does not mean always working in black and white, or only using neutral colors like brown or gray. You can also paint with blue, violet, or red. Colors that are too light like yellow and yellow ochre should not be used, because they are too luminous and do not offer a wide enough tonal range. It is a good idea to begin painting simple objects, such as bottles, fruit, fruit bowls, or pitchers, and try to represent them with only blue.

WHITES WITH ACRYLIC
When painting with a monochrome wash the whites are usually obtained by leaving some areas of the paper or canvas unpainted. However, if you forget to do this, you can fix the drawing by using white paint in the final steps, so you can put a little on your palette just in case.

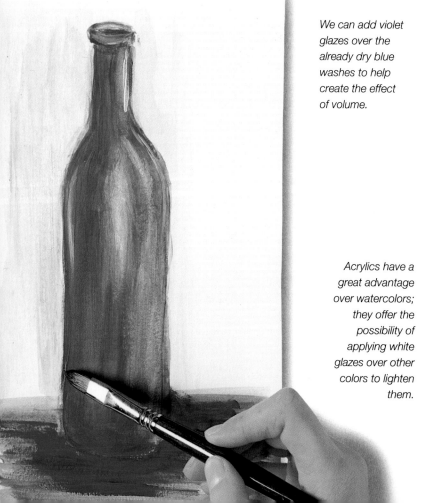

We can add violet glazes over the already dry blue washes to help create the effect of volume.

Acrylics have a great advantage over watercolors; they offer the possibility of applying white glazes over other colors to lighten them.

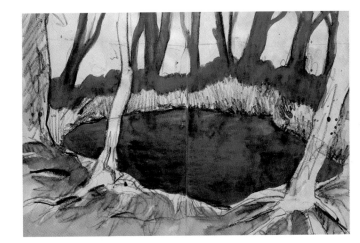

1

A RED WASH

This is a simple exercise, but it will be very helpful in understanding how to work with a monochrome wash. Take a previously made drawing and apply a first wash of red. Apply it only in the areas where the shadow is darkest. Allow the color to dry, and with a second wash you can darken some parts of the water and shade the trees, this time with more diluted paint. Then with a third wash of white paint lighten the reflections in the water so they look like the reflection of the trees in the background.

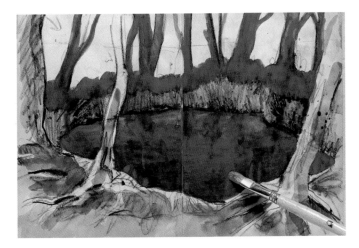

2

3

1. We indicate the most strongly shadowed areas of the model with the first wash.

2. The second wash intensifies the previous tones and creates the medium tone shadows.

3. To finish, the reflections in the water are lightened with a wash of white paint.

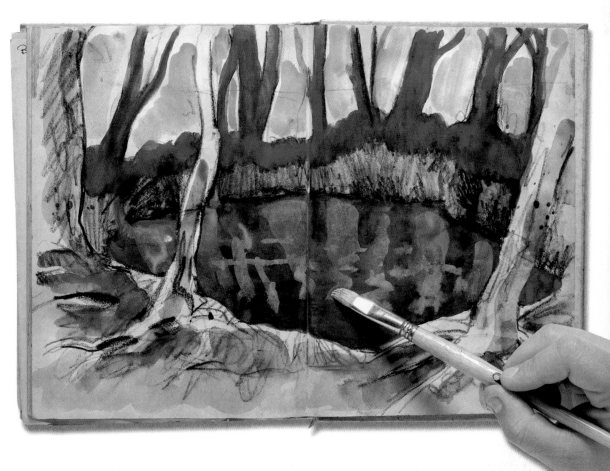

Creative Approaches

ÀLEX SAGARRA. *CONVERSATION WITH TREES, 2007.*
ACRYLIC ON A TEXTURED GESSO BASE

with Washes

Until now we have studied the traditional way

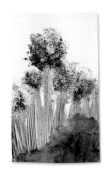

of working with washes; in the next section, we will analyze various examples that render fresher and more creative results, some of them exclusive to acrylics. They are based, in general, on impact, on surprising the viewer with a finish or a texture, which makes the drawing less important and reaffirms the importance of the paint and its expressiveness.

Washes over Textures

Glazes are not at odds with impasto and textures. A glaze, a wash of very diluted color, can be applied over a previously applied impasto, an area showing some texture. The wash will highlight the relief effect of the paint.

GLAZING OVER WHITE PASTE

First the surface of the support is prepared with modeling paste or gesso. The paste is spread with a spatula and modeled with the forms, texture, and marks to your liking. After the gesso has completely dried it is painted over with very diluted colored glazes. The diluted paint is deposited in the cracks and highlights the relief of the surface. Once the acrylic has dried it looks as if the impasto has been applied with the color of the glaze.

TRANSPARENT IMPASTO

Glazes can also have relief; they should not be limited to a thin layer of color. A small quantity of paint mixed with a large amount of acrylic gel creates color effects that look like stained glass if it is added to a surface with some color already applied.

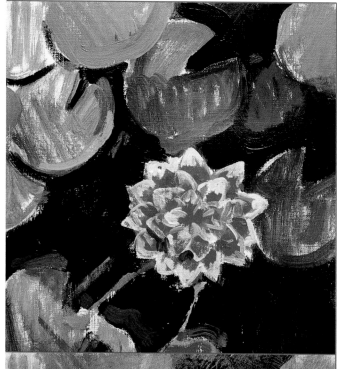

You can make a glaze with transparent impasto over any painting to change the general tonality of the color and to create a relief effect at the same time.

When you apply a glaze to a textured surface the color is deposited in the low areas and highlights the relief effect.

A SIMPLE EXAMPLE

Begin with a cardboard support that has a previously prepared collage of different colored papers, and choose an area to apply an impasto with gesso. Model the paste by making circular movements with a spatula to help illustrate the forms of the lemons. Allow the gesso to dry for several hours and then apply glazes of yellow, green, and burnt umber (in that order) over the lemons. The glazes will lightly blend with each other, penetrating the low areas of the texture. While you let the colors set and dry move on to other parts of the painting to finish it.

It is a good idea to practice modeling with gesso and a spatula. Using any paper, try to become familiar with the medium by making impastos and different marks.

1. Add the white paste or gesso with a spatula to the painting and model it until achieving the desired shapes and textures.

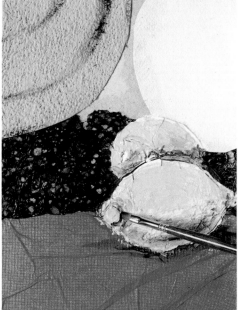

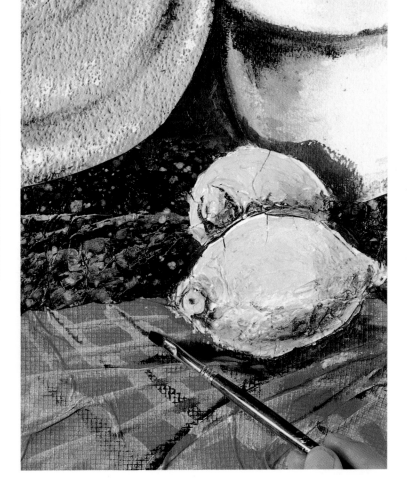

2. When the gesso is dry apply the glazes, mixing several colors, which will find their way among the cracks and spaces of the white paste.

3. While you let the washes dry, complete other details of the painting, always keeping the support flat on a table.

This consists of creating a painting by accumulating very diluted paint on the support, laid flat on the table, creating puddles where the paint collects. In this way the washes cause an irregular distribution of color and very wavy and fluid shapes.

Puddles, Concentrating the Water

INTERRUPTING THE DRYING

Puddles allow you to interrupt the drying process before the water evaporates completely to create lines and areas without paint, creating a very interesting graphic effect. This technique is exclusive to acrylics, and owes its success to the fact that acrylic washes do not dry uniformly but from the edges inward. This means that if we dampen the wash with water before it is completely dry, the dry paint will stay around the edges while the paint in the center of the wash will disappear and leave white areas.

LET'S EXPERIMENT

Before putting it into practice it is a good idea to experiment on a paper or piece of cardboard. First draw a line with a lot of water and wait a few minutes until it begins to dry. When the edges of the wash have dried completely put the cardboard under the water faucet or wipe it with a damp sponge. The result is a strongly outlined mark with white areas inside. If the test has been successful it is time to take a stab at a still life.

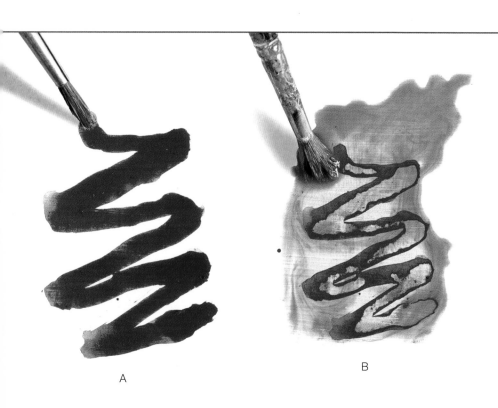

To create white areas within a puddle apply a wash in a zigzag shape on a nonporous support, and wait a few minutes for it to dry (A). To interrupt the drying process pass a wet brush over it. Then, clean the surface with a damp sponge (B). After completing the process the paint looks like this. The wash has only partly dried, leaving an inconsistent line with a lot of graphic interest (C).

A

B

C

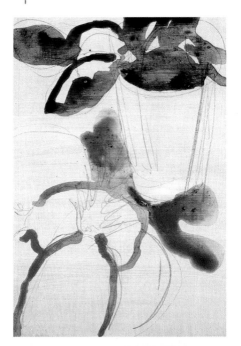

A STILL LIFE WITH PUDDLES

To paint with puddles you must work on a barely porous surface that will allow the washes to accumulate. If you are going to paint on cardboard it should be primed with gesso or white acrylic. Make a puddle by loading the brush with a very diluted color and apply it to the support without much pressure on the brush; simply deposit the water to form more or less uniform areas of color. Then wait for the washes to dry before adding more new ones. It is also possible to make white areas with a damp sponge, as we explained, interrupting the drying process. Painting with puddles means working unhurriedly, over several hours, so that the washes can sit and dry slowly. Therefore, be patient.

We cannot offer any time reference for successfully eliminating part of the color from a puddle. You must experiment and see for yourself how many minutes should pass. Remember that the drying times will vary a lot depending on whether you are in a humid or dry climate, or in summer or winter.

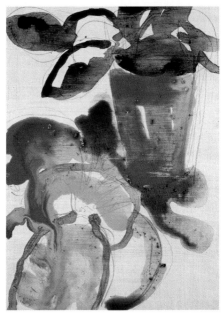

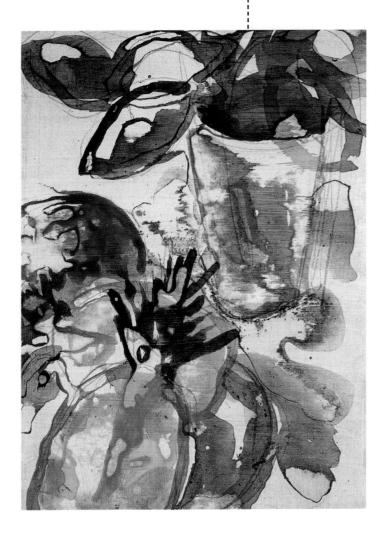

1. Liberally apply the first washes to a cardboard support primed with gesso. Your objective is to cause the paint to puddle and for the paint to spread in an irregular manner.

2. New puddles are added over the previous ones to add more interest to the picture. Try not to tip the support; it should always lie flat.

3. If you keep each puddle from drying completely and you wipe it with a damp sponge, and repeat this several times, the result will be very similar to this.

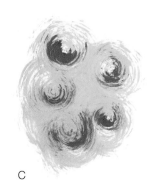

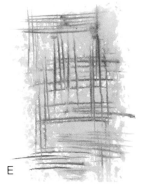

A

B

C

D

E

F

Sponge
Effects

Acrylics allow the artist to experiment with different ways of applying the paint to achieve new textures and effects. In this sense, sponges become very prolific at creating special textural effects.

VARIOUS TYPES OF SPONGES

The results achieved with the paint vary according to the sponge that is used. Therefore, it is worth having different types of sponges at hand and experimenting a little in the beginning. Painting with natural sponges creates irregular color effects and irregular tones on the painted surface, giving it a decorative look. Artificial sponges come in many different shapes and sizes, and they can create very diverse textures by simply pressing on the support. The roller makes straight edges and interesting gradations of single or multiple colors. The sponge brush is ideal for making striated lines and linear or gestural marks that are graphically interesting.

A. Dragging is one of the main sponge effects. It can spread a dense color very quickly.

B. If the sponge holds little paint, dragging it will create a very interesting texture.

C. The circular forms are made by rotating a corner or edge of the sponge on the paper.

D. If you press hard on the paper with the sponge, without moving it, you will create a granulated texture.

E. Linear marks can be made by gently pressing the beveled point of a spatula-shaped sponge.

F. Instead of working with the beveled edge, lightly press the corner to make triangular marks.

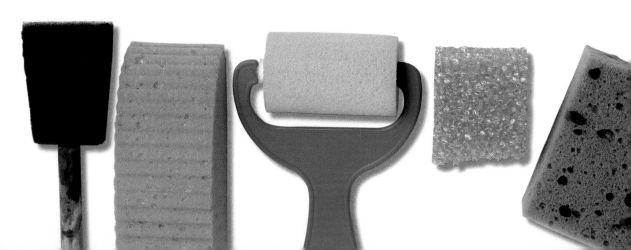

Various sponges for working with acrylics: a spatula shape, a roller, some synthetic sponges, and a natural sponge.

HOW TO SATURATE
THE SPONGE WITH PAINT

Before you begin to work here is some advice. First, it is important to wash the sponge several times before using it to eliminate all the dirt and sand it may contain. The paint should be prepared beforehand in a plastic dish; it should be neither very liquid nor very thick. Wet the dampened sponge in the paint until it is thoroughly soaked. Squeeze it and absorb the excess paint in a paper towel. If it has too much paint the finish can be uneven and splotchy.

BLOTCHES AND LEMONS

Make several tests on pieces of paper; it will just take a few times to see what can be done. On this page we show some examples that you should practice. Then, we attempt painting a small still life—a couple of lemons on a tablecloth that we can create with two different interpretations. In the first interpretation, paint by pressing the sponge lightly and quickly on the background and on the lemons. The look or the resulting texture will vary according to the number of colors that are applied. The tablecloth is painted by dragging a sponge brush. In the second version, the lemons are made by pressing and dragging with diluted paint. Later, when the paint is dry, the shapes are drawn with a sponge roller charged with brown paint.

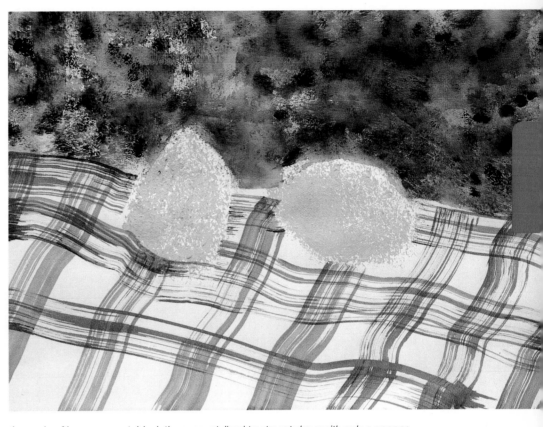

A couple of lemons on a tablecloth, a very stylized treatment done with only a sponge.

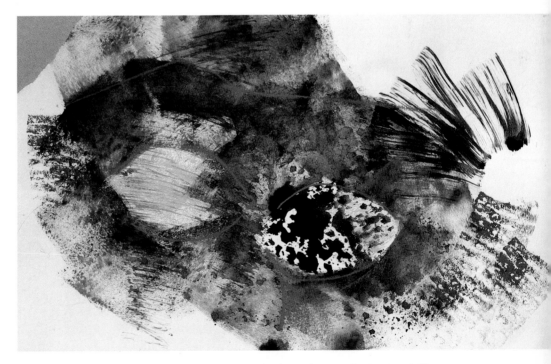

This is the same subject as before with a more imaginative and expressive treatment. Here we combined various lines and textures made with sponges.

Exercises with
Sponges: The Brush and the Roller

You can interpret any natural model without using brushes. We have decided to demonstrate how to achieve interesting results by experimenting with different sponges, which will help increase the creativity of the artist and his or her knowledge of the acrylic medium.

BRUSH-SHAPED SPONGE

Sponges are basically used to create the illusion of texture on a surface, but there are other alternatives like sponges in the shape of a brush. This too has a wood handle to facilitate its use. It can be used for washes that are more or less linear, and they make very characteristic striations. If it is saturated with diluted paint the mark is very fluid; if it is merely damp

it will be dry and striated. Take a piece of paper to try out this tool and study its possibilities.

CONSIDERATIONS ABOUT COLORS

The color and tone require careful selection, since applying it with a sponge can turn out very crude if it is not used delicately. Start painting with soft light colors, which we will darken as the work progresses; this way the surface of the support will not become saturated with color and the final result will have some contrast. Be sure that the base coat and the successive decorative layers highlight the form of the subject represented and that the colors do not give the impression of little contrast and excessive definition.

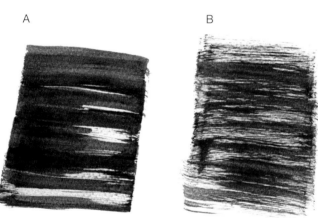

A B

Two marks made by dragging the sponge brush. The first, charged with more water (A), has a more covering stroke than the second (B), which is only damp.

The sponge brush can hold a lot of paint and makes marks that are more or less linear and of varying widths.

A FLOWERPOT MADE WITH A SPONGE

The first color to be applied is the base, the background; the predominant color in this case is raw sienna spread with a sponge roller. The color should not be too liquid so the paint will not run. Let the paint dry before continuing. Drag a small piece of sponge loaded with an intense orange to paint the flowerpot. Construct the leaves with the brush sponge, which will give them a linear feel. Highlight the illuminated areas of the subject and bring back some of the outlines using a sponge roller loaded with white paint. Remember that white is more opaque when it is wet, which means that after it is dry the colors underneath will show through.

When working with sponges the darker colors are normally applied over lighter ones, and not the other way around.

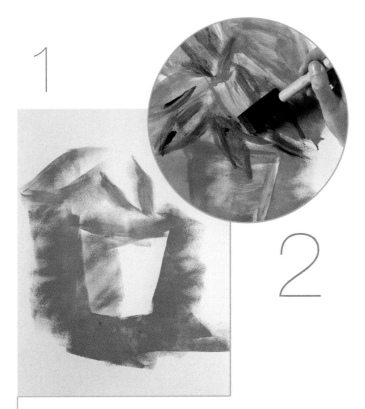

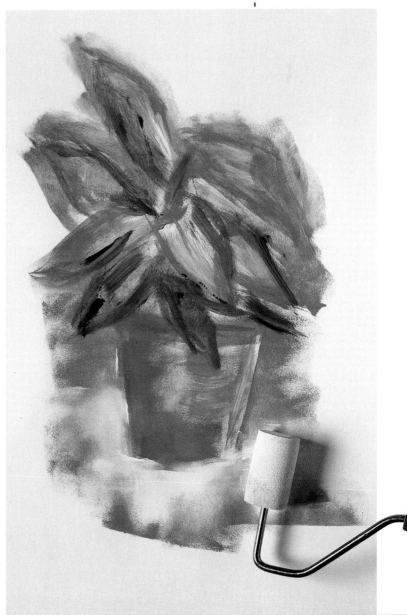

1. Apply the shaded background using a sponge roller loaded with brown paint.

2. The sponge brush is best for linear work and dragging color.

3. You can overlay some colors over others; just keep in mind that when they dry they become a little more transparent.

Opaque Tech-niques with Acrylics

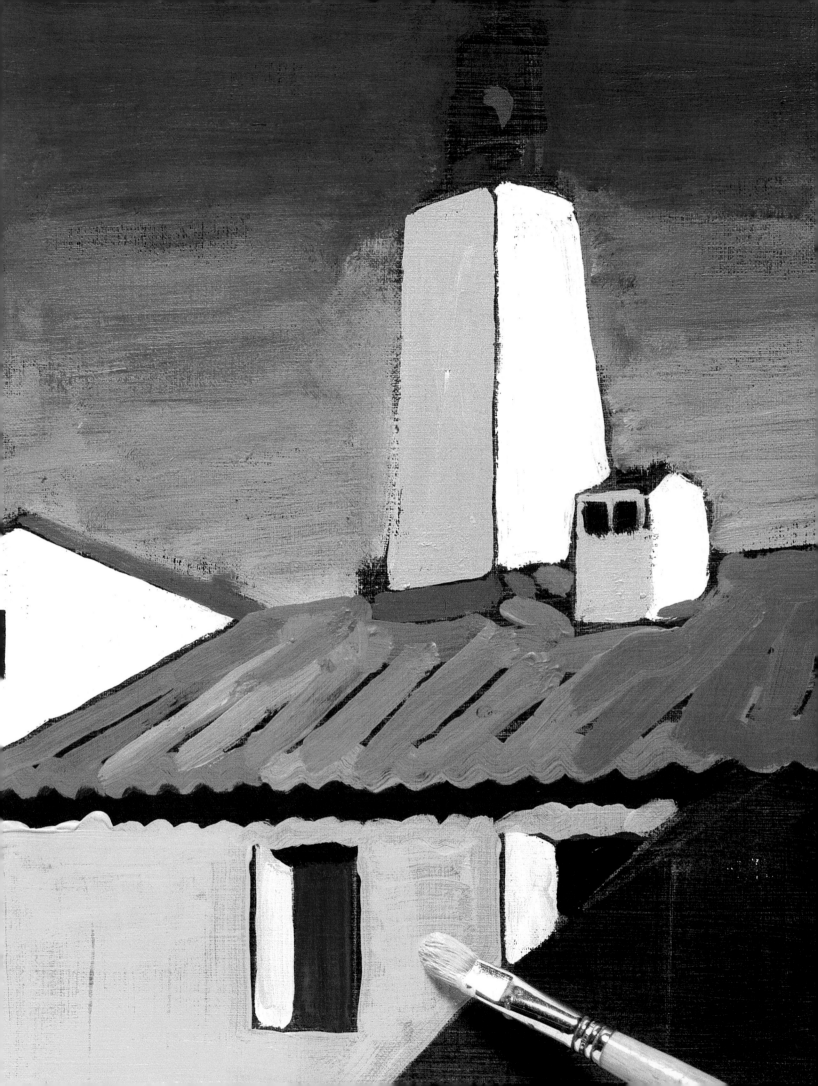

Thick Paint: Painting with

GABRIEL MARTÍN. APPLE AND BANANA, 2007.
ACRYLIC ON CARDBOARD

Opaque Color

Besides being appropriate for creating transparency effects,

acrylic paint can also be used for various opaque color techniques, that is, working with creamy thick paint whose strength is based on intense color and solid construction. If the acrylics are used without diluting, or a medium is added to give them more volume, they can even strengthen the texture because the brushstroke can be seen. Acrylic paint adapts very well to this way of working, and since mistakes can be corrected by painting over, this is a good way to learn to paint.

Opaque Applications of Color

If they are used directly from the tube, acrylics have a thick consistency and the color is denser. They can be used to paint one over the other, covering the colors underneath to modify or complement the painting, or to cover a previously used support with a medium or dark base.

PAINT WITH CONSISTENCY

Undiluted acrylic paint has a thick consistency that will easily cover any colors that are underneath it. If for some reason it does not, a little white of gesso can be added to the color to make it more opaque. Working with dense and opaque colors favors expressive brushstrokes. Wide brushstrokes can be used to quickly sketch a model. It is best to use a thick, round brush, which will keep the work from becoming too complicated, and keep us from getting caught up in the details. Try not to apply too much paint because the glossy finish of the acrylics will make the surface look plastic.

BLENDING COLORS

Acrylic paint can be blended the same way as oils, spreading bands of color and blending the adjacent edges with a clean bristle brush. The fast drying acrylics can present a problem for this technique. The solution is adding a retarder to the paint right on the palette. This increases the drying time and allows you to carry out the blending.

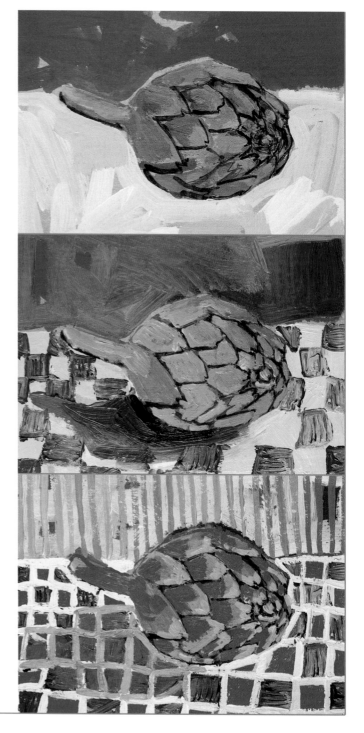

Working with opaque colors allows you to constantly change the appearance and the colors of a picture by painting over previously applied colors. Here are three sequences where the appearance of the painting is notably modified by superimposing layers of opaque color.

If you wish to blend colors you should make sure the paint is wet; otherwise you should add an acrylic retarder to each color.

If you want a brushstroke to be opaque, you should not mix too much medium with the color, since that will affect the opacity of the paint.

NOT ALL COLORS ARE OPAQUE

Some acrylic colors are naturally opaque, like ultramarine blue, cadmium red, and yellow ochre. But others, because they incorporate less pigment, are more transparent; an example of this is the yellow range or quinacridone red. Painting over bright colors with them can be a problem, because an apparently opaque yellow becomes transparent when it dries. To avoid this problem it is a good idea to prepaint the area in question with a layer of white paint. When it is dry you then cover it with yellow so that the paint will not lose intensity and will look clean and bright.

Be careful when applying yellow paint over a darker background, since it tends to become more transparent when it dries.

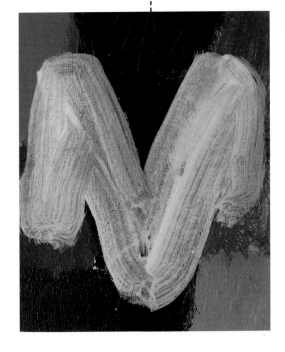

Acrylics can be applied as opaque brushstrokes, which allows you to work on bright backgrounds without them showing through and affecting the colors you are using.

If you want to keep the intensity of yellow paint on a dark background, you should first paint the area white, allow it to dry, and paint yellow over it. After it dries the yellow will look saturated and luminous.

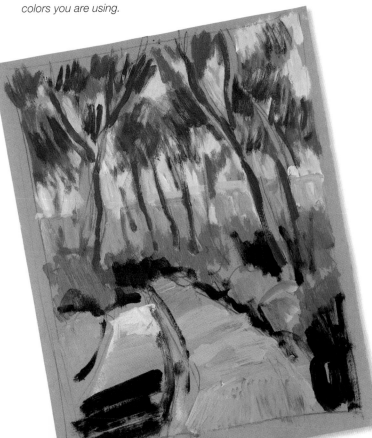

Since acrylics dry very quickly, a good way of working is to apply the paint layer by layer, juxtaposing areas of thick, uniform color. That is to say, the model is constructed of clearly differentiated tones, without any blending of the colors, with no gradations. This way of working is quite similar to the techniques used for applying gouache colors.

Gouache Techniques Used for Acrylics

A TONAL SCALE

Opaque color techniques typically used with gouache can also be used when painting with acrylics. However, since they are neither as opaque nor as soluble as gouache they do not flow in the same manner. Since we are going to work with flat areas of color where there are no gradations, the volume of the objects will be indicated by scaling the tones of the light. To begin, you will learn to construct a tonal scale with colors. You can use an intense black for the darkest area and a light green for the lightest.

VOLUME THROUGH TONES

The plan is to apply a tonal scale to an object to give it volume. It is a good idea to choose a simple model; in this case a red ball. Paint the shadowed areas with a mixture of black and red, and from there, as you move toward the light source, the red will become more intense, lighter, and even whiter.

SIMPLIFYING COLORS

Working with areas of flat color means simplifying the model, establishing its main zones of tone and color. This way you can concentrate on the basic structure of the model without worrying about the shapes on the surface or details that might distract you. Many artists believe that simplification is a useful point of departure, a first step before developing the subject in detail. As an example, we have painted a tree with areas of flat color. First, two green tones were painted in the treetop. The trunk and branches were painted with orange sienna. The same greens, along with an intense orange, are used to paint the ground. Then the background is finished with light orange.

You can put the tonal scale into practice to represent the volume of an object with a single color.

In the tonal scale, colors of decreasing intensity are juxtaposed in small tonal steps moving from dark to light.

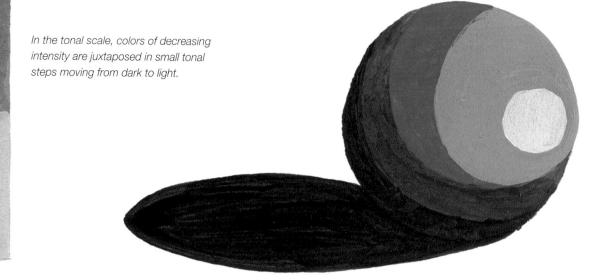

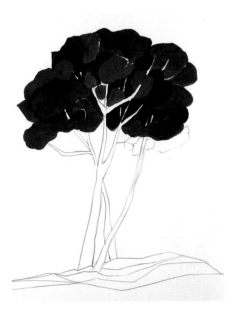

1

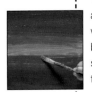

To make smooth areas of deep color, with few or no brushstrokes, apply several coats of thick paint.

1. The treetop was painted with two tones of green. One color must be completely dry before applying the next one.

2. A fine round brush and much care were used to paint the branches and trunk. The same greens as before were used to paint the ground.

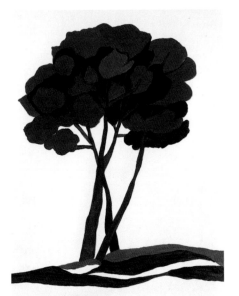

2 3

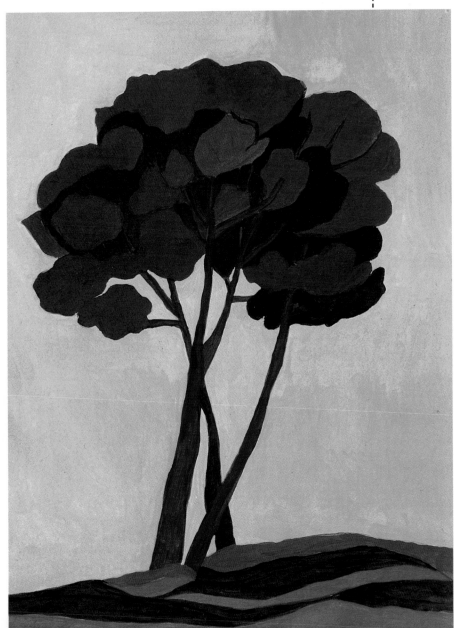

3. The last areas of flat color were orange, an intense tone on the ground and a lighter salmon color in the background.

How to Model Acrylics
If They Dry So Fast

Modeling is the name for blending one color with another to form gradations and smooth transitions of color. Because of its fast drying time, acrylic paint can only be manipulated on the support for a short amount of time; it does not lend itself to modeling techniques typical of other kinds of paint. How do you solve this problem?

BLENDING WITH BRUSHSTROKES
The thicker the layer of paint, the longer it will stay wet, and blending the colors will be easier. If you wish to avoid this inconvenience, you can add a little retarder to the mixture to work more comfortably. This will allow us to blend the different colors with the brush, leaving directional strokes so that each one plays a creative role. The shape of each brush determines the mark that it will make, the texture of the area, and the direction of the vegetation. Acrylics conserve the brush marks very well, so that it would be a shame to ignore the possibilities. Let's take a look at this quick landscape study.

THE BEST OPTION
It is possible to extend the drying time by adding a retarder when mixing the colors. This gives us more time to manipulate the paint on the surface and develop good modeling with well-constructed gradations. Let's compare the last gradation, done using this method, with three previous ones.

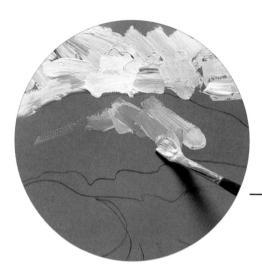

If you are going to blend colors, do not work on different parts of the painting at the same time. Begin at the top and work your way down. Here some still fresh blue and yellow brushstrokes are mixed together.

If you paint with new colors on areas of the landscape that are still wet you will drag part of the color from underneath, and this will help unite the previous layer and the new color.

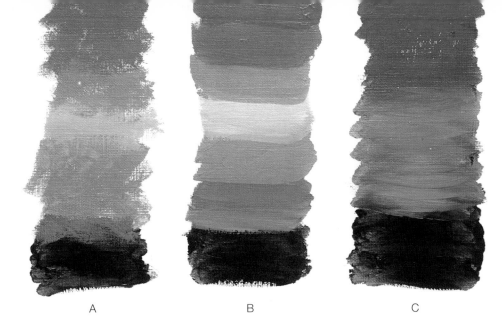

Three different ways of modeling with acrylics: with nearly dry brushstrokes (A), making a tonal scale (B), and blending the colors with each other while they are wet (C).

A B C

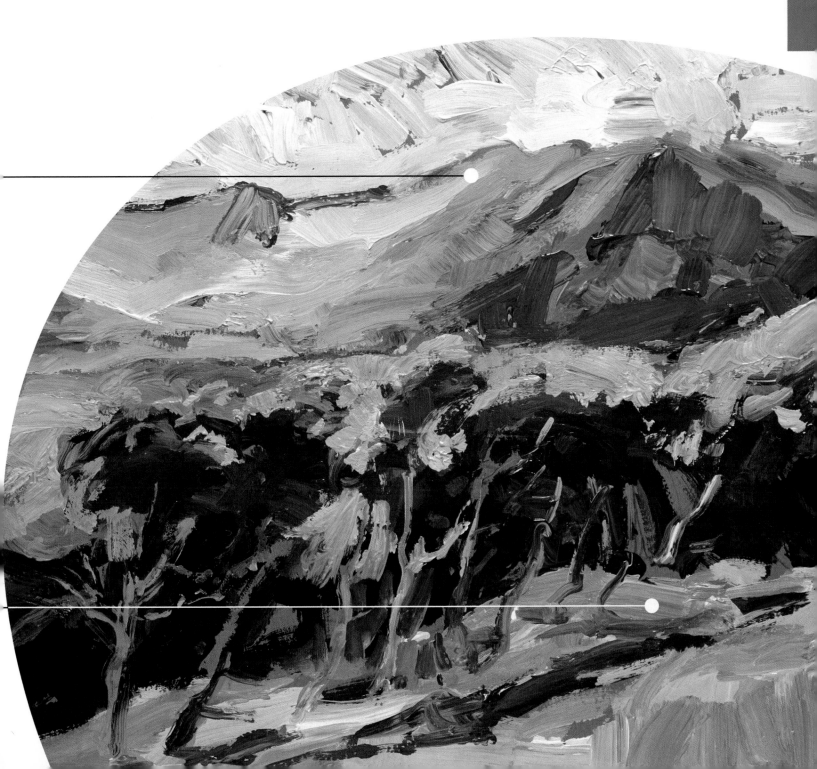

Working
with the Spatula:

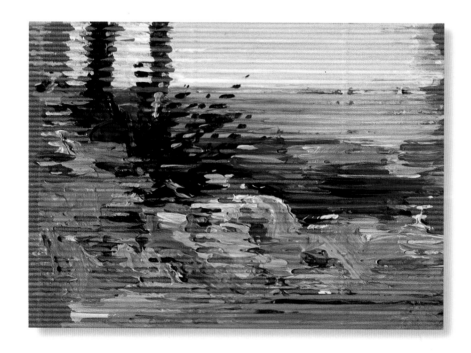

ÓSCAR SANCHÍS. *COASTAL LANDSCAPE, 2007.*
ACRYLIC ON TEXTURED CARDBOARD

Dragging Paint
The technique
of spreading acrylics

with a spatula or a scraper opens up a large number of possibilities; its more or less sharp straight edge gives you the ability to spread the paint by dragging. The colors mix on the support, and one color lays over another to produce curious results. In principle, the technique of working with acrylics and a spatula is not widespread, although the results can be as gratifying as those achieved using a brush.

Impasto
with Brush and Spatula

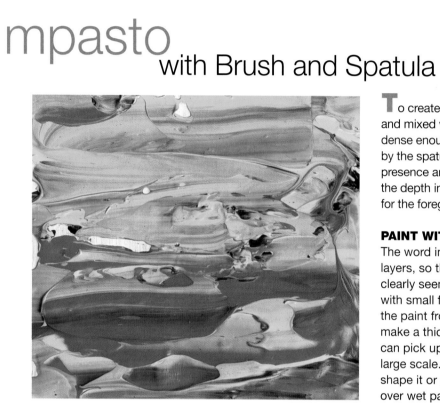

To create impasto, acrylic paint is used directly from the tube and mixed with a thickener. The paint should be malleable, but dense enough to conserve the lines and brush marks made by the spatula and brush. Thick paint has a strong physical presence and it tends to advance, so if you wish to maintain the depth in a composition you should reserve the impasto for the foreground of the center of interest.

PAINT WITH RELIEF
The word impasto describes the paint that is applied in thick layers, so that the marks of the brush or the spatula can be clearly seen. Square or flat brushes are the best for working with small format impastos, since they allow you to pick up the paint from the palette as if it were a shovel and use it to make a thick, dense brushstroke on the support. The spatula can pick up more paint, and is a better tool for working at a large scale. It is better for modeling the impasto surface to shape it or give it the desired effect. Anytime paint is applied over wet paint it will drag some of the color from underneath and create an interesting striated effect.

Impasto done with a spatula will create a strong relief and the paint will mix on the support to make bands of dragged color.

If the support is very large you can save paint by making an impasto with gesso on the base coat.

A rose. These methods are more appropriate for decorative work or semiabstractions than for figurative compositions.

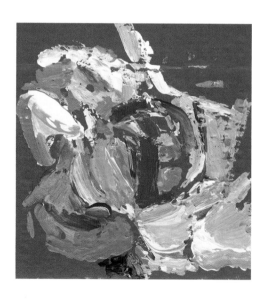

There is a special paste made for impasto work, heavy gel medium, which is mixed with the paint to increase its volume.

SKETCHES WITH IMPASTO

A little bit of impasto prepared with a spatula will liven up any composition, creating a fun textured sketch based on a photograph. The best way to practice is to take three or four photos and sketch them with a few strokes of thick paint using a spatula. The point of this exercise is to learn to apply paint with a spatula to the support and to make textured paint. You do not have to worry too much about making a very exact or detailed representation. Here are a few examples that we invite you to copy.

HEAVY GEL

To increase the volume and quality of the impasto it is best to add thickening gel to the mixed colors. It is especially used for spatula work, when the surface of the painting is large; then the gel becomes a way of not using too much paint. Two things should be remembered when using gel: Heavy gel should not be used with a filler; it should have a thick consistency, but soft, which increases the volume of the paint. Another way to save paint is to prepare the support with gesso beforehand, to model and add volume to the subject with the white paste that dries rapidly.

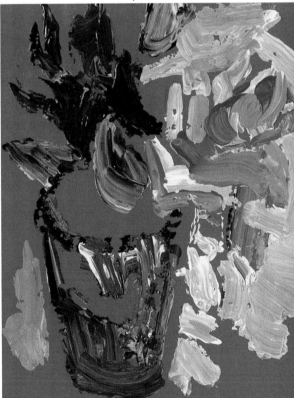

A pot with flowers. It is better to use textures creatively than to try to imitate reality.

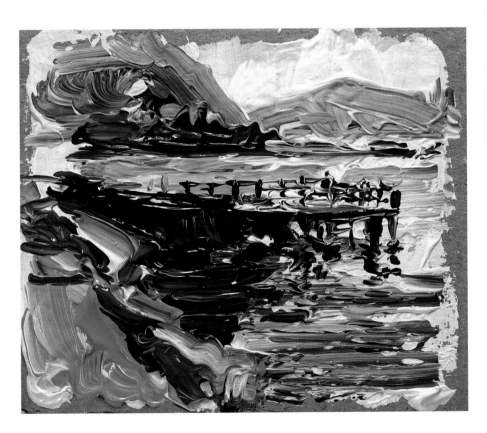

Some impastos made with a brush over a base of white paint that was still damp.

The creamy consistency of acrylics allows them to be used for painting with a spatula, a tool that has a flexible metal tip available in different shapes and in a variety of sizes. They usually have a sturdy handle for good control when moving the paint around on the picture without damaging the canvas or scraping the paint. The long and flat blades are flexible and ideal for applying large areas of paint. The smallest diamond shape tips are best for smaller paintings and for more controlled painting. The plastic spatulas made specifically for acrylics are not recommended. Instead, spatulas made for oil paints work better as long as they are stainless steel.

We made small overlapping impastos in the branches with the tip of the spatula, just like brushstrokes are applied.

Different Ways
of Spreading Paint with a Spatula

THE ADVANTAGES OF THE SPATULA

Painting with a spatula allows fast work, and the results can be fresh and spontaneous. The secret of a good spatula painting is working with sureness and confidence, spreading the paint by moving the hand. It is not the correct approach when the model requires a large amount of detail.

Before setting off to do an entire painting it is a good idea to do some experimenting on a separate paper or make some color studies like this pine forest. This composition was deliberately made with few complications, and there was little need to begin by making a drawing. It was enough to cover the background with blue paint. Then areas of color were resolved with a spatula. When a new color is added before the previous one has dried, they blend and do not leave clear edges between colors, rendering interesting results. The thickness of the paint and the small amount of color mixing lend the painting a very expressive and colorful finish.

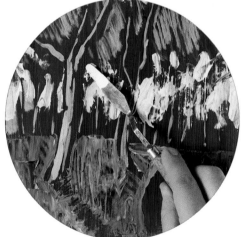

Spatulas are not used for details. To represent the areas of light coming through the branches bluish white paint was applied using a spatula with a round tip.

In the lower part of the vegetation, the paint is dragged with a flat spatula that blurs the edges of the colors and makes them blend better with the underlying colors that are still wet.

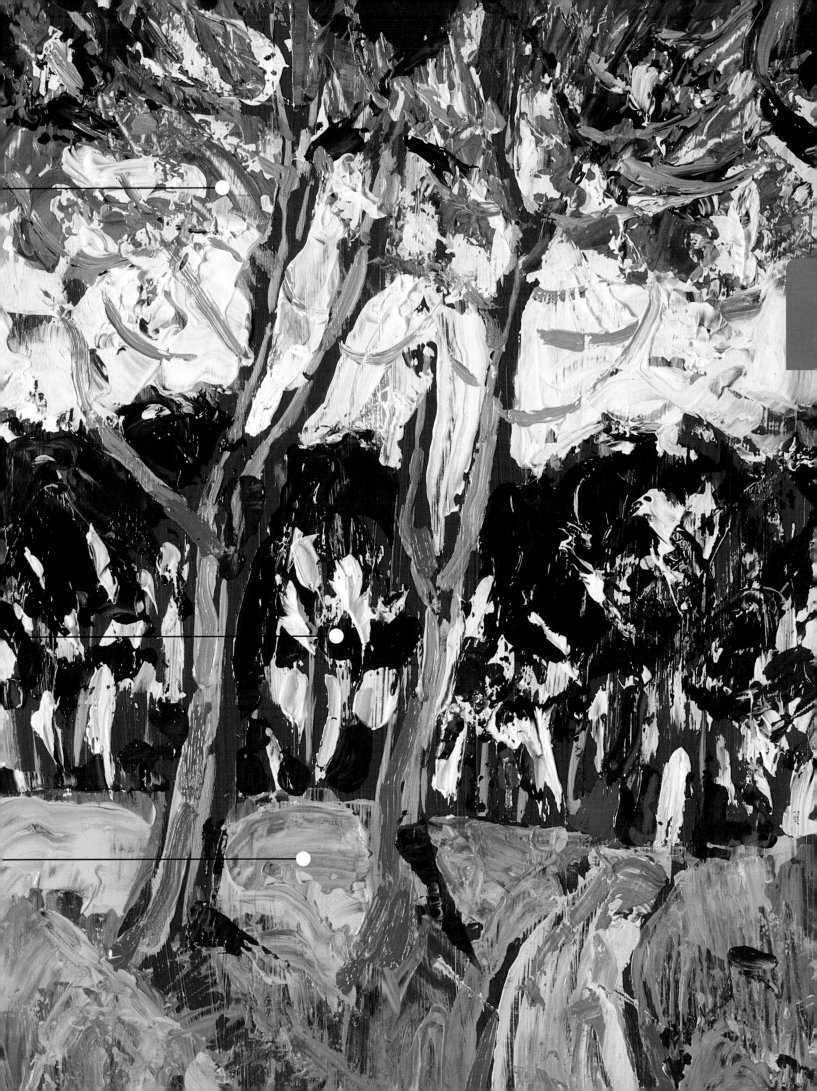

Scraping and Dragging Paint

The paint can be applied as an impasto with a flat spatula, but there is also the technique of scraping the color across the surface. This means working with the edge of the spatula blade or using a flat scraper and pressure to make thinner layers of paint with striated color mixes.

DRAGGING THE PAINT

The scraping or dragging technique basically consists of distributing the paint across the surface with a spatula or an object with a straight edge. If you press firmly with the spatula when you drag, the paint layer will be very thin and will produce an effect similar to a glaze. In order to cover the entire surface with one single pass of the

scraper you must deposit enough paint on its edge. If it turns out that some of the paint is wasted this way, it is justified by the wide range of possible effects.

MIXING COLORS BY SCRAPING

The action of scraping blends colors as they overlap each other at the edges, but the pure color stays intact in the center of the stripes. Even if you move the spatula in a zigzag motion, the color bands will barely be altered and will continue to follow the stroke. The best way to approach this technique is to slightly mix the colors on the palette so they will form the distinctive stripes on the support later.

The paint is dragged with a flat spatula like those used for stone masonry to create a thin layer of color.

Mixing the paint by scraping forms very distinctive bands of color.

Dragging paint with a spatula on damp paper creates transparent lines that do not contrast much with the white of the paper, and their edges are very attractive.

Normally this is done with flat metal spatulas; however, scraping can be improvised with a ruler or some pieces of plastic or cardboard, or an old credit card.

SCRAPING ON WET

Using the scraping technique on damp paper makes interesting effects. In the first place, the paint does not adhere easily, so that the marks from scraping can be seen but the colors do not cover the paper but just lightly stain it, and the layer of paint looks broken and transparent. If you wish to paint by scraping on wet, it is best to practice on a damp piece of paper and to become familiar with the effects that are produced.

A SCRAPED BACKGROUND

Spreading paint this way can be useful for creating multicolor effects on backgrounds, using the paint directly from the tubes or diluting it with water or acrylic medium.

Another method, different but efficient, consists of spreading or scraping the entire surface of the painting using an improvised scraper: a squeegee or a ruler. You can use this method on a much larger scale working on the length of the canvas instead of on small parts of it. The colors will not contaminate each other in the scraping technique, as long as it is done with a firm and fluid movement.

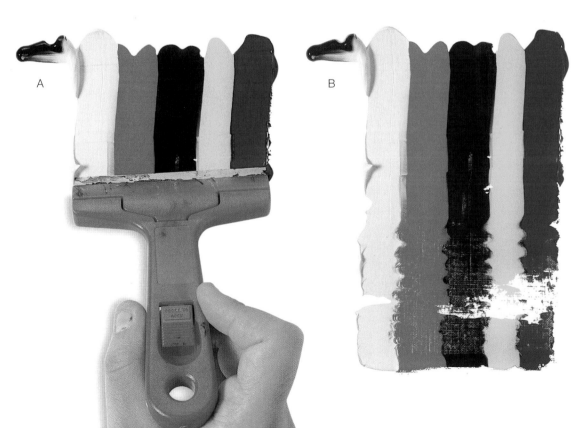

A

B

A. It is possible to prepare the background of a paper by scraping paint across it. First you place different colors in a line, taken directly from the tubes, and spread them with the widest scraper you have.

B. The paint is spread, forming clear and separate bands of color. This was done with a plastic squeegee.

Blending Colors

Using flat spatulas to drag the paint on the support is a great advantage, since it allows you to concentrate on constructing a painting based on masses of color, studying them to see how they interact with each other, and forgetting about the details since it is not possible to reproduce them with this technique.

TWO WAYS OF MIXING COLORS

There are two basic ways of blending colors when using the scraping technique; the first is charging the tip of the spatula with two or three different colors. Then the colors blend with each other by the dragging action to form bands of color with slight gradations between them. If you want a stronger mixing effect you just have to move the spatula back and forth slightly as you spread the color.

The second technique consists of making transparencies. If you add a little medium to the paint and to make very thin layers of paint when you scrape, they can be applied one on top of the other like glazes. Using this technique you can darken a color or change its tone.

DRAGGING A ROCKY LANDSCAPE

Practice will tell you which is the best way of applying paint by dragging. To start, the model should be simple and we will limit the mixing in each application to a maximum of two colors. The painting is constructed by synthesizing the main colors of each area and taking care to create contrast between the zones of light and shadow. Mix blue and carmine with the browns of the shaded areas and violet and white with the ochres that will define the illuminated areas. The sky should be more like glazing, with thinner layers of paint. Add a little transparent medium to the mixtures of blue to strengthen this effect.

You can make the mixed colors more expressive by moving the spatula side to side as you drag the paint.

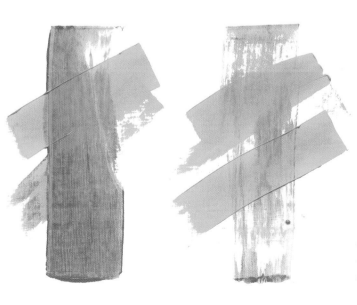

Here are two examples of scraping with a glazing effect. If you superimpose the "transparent" colors over those that are naturally opaque you will achieve better results.

1

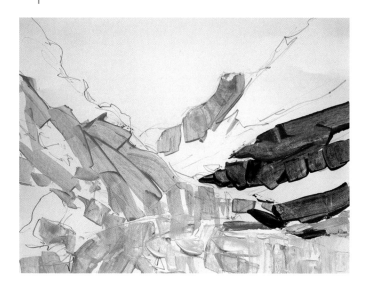

1. The first strokes should be made with only two or three colors. The direction of the dragging should be in accordance with the inclination of the mountainsides.

The palette knife should only be used when you want to make some sgraffito while the layer of paint is still wet.

2. Shade the previous colors with new applications. Notice how the ochre is toned down with a new layer of whitened ochre.

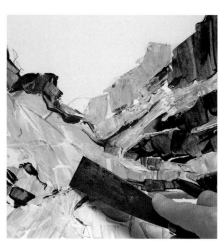

2

3. The dragged paint is not applied uniformly. It is important to add variety to the composition, contrasting areas of flat thin paint with others that have a lot of texture.

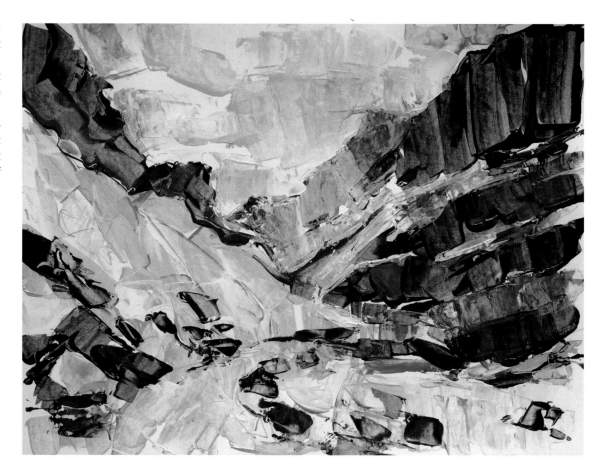

3

"MY RELATONSHIP WITH THE MATERIALS I USE IS THAT OF A DANCER WITH HIS PARTNER, A RIDER WITH HIS HORSE, OF THE PSYCHIC WITH HIS TAROT CARDS. SO IT IS POSSIBLE TO UNDERSTAND THE INTEREST THAT I HAVE IN A BRAND NEW MATERIAL AND MY IMPATIENCE TO TRY IT."
Jean Dubuffet. En Cirlot, L: The Latest Painting Trends.
Visual History of Art, vol. 17, page 8. Vicens Vives, Barcelona, 1990.

Effects, Textures, and Creative Approaches

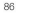

Effects with Colors

and Reserves

These are achieved by varying the texture of the surface of the paper,

the color of the background, and making use of the rejection or the incompatibility that exists between acrylics, a water-base medium, and wax crayons with an oily base, to create a number of new effects and new color treatments that you should assimilate and incorporate into your repertoire. In the following section we analyze some uncommon methods of applying color with very gratifying results, that professional artists resort to often.

Dry brush refers to a technique of applying color that basically consists of painting with dry paint in the brush. This means that it is not very diluted with water, since the paint should never actually be "dry."

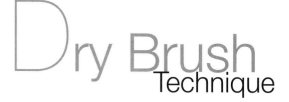

Dry Brush
Technique

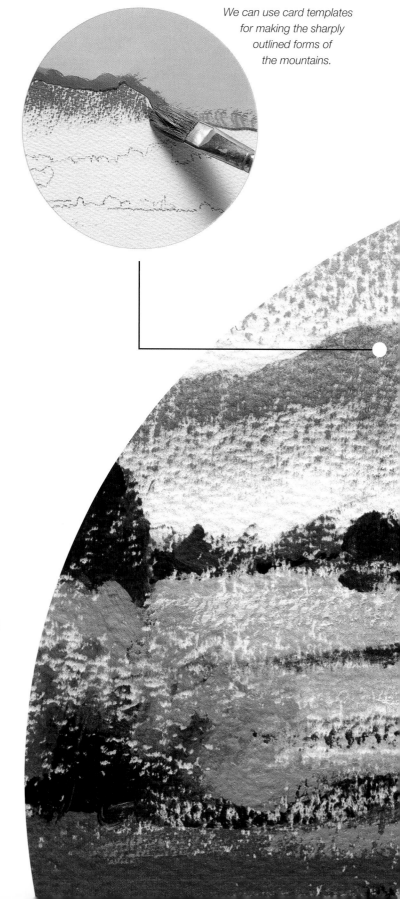

We can use card templates for making the sharply outlined forms of the mountains.

APPLYING THE LEAST AMOUNT OF PAINT

Dry brush is a common technique in all paint media, whether opaque or transparent. It is done by putting a minimal amount of paint in the brush, eliminating the excess, and immediately wiping several times on a paper. You then paint with what is left in the brush, preferably on a support with a rough surface. A brush with stiff bristles is recommended for painting with the dry brush technique. If you think you will be using this technique often it would be a good idea to have several brushes because they wear out very quickly.

A DOTTED EFFECT

Dry brush is based on a very simple premise: when a brush holds very little paint it will only deposit paint in the areas of most relief on a rough surface. The paint will only adhere to the grain that stands out from the paper and the result is a dotted surface.

If you try the same technique on a smooth and glossy support you will see that it does not retain the paint in the same way as a rough surface or canvas. Therefore, dry brush creates a characteristic scraped, broken, and rough brushstroke.

A MISTY LANDSCAPE WITH DRY BRUSH

Here is a simple exercise to put the dry brush technique into practice. The support should be rough, for example a grainy paper like those made for watercolors. Since it is very difficult to draw clear lines with a dry brush, we take a piece of poster board that has previously been cut into the outline of some mountains. We use it to reserve the sky and create a clearly defined outline. Then we paint the sky with a little more violet in the upper part and a bit drier in the lower. With brown and green we paint two wide bands in the landscape. To finish we detail the vegetation using a fine round brush with a little more paint.

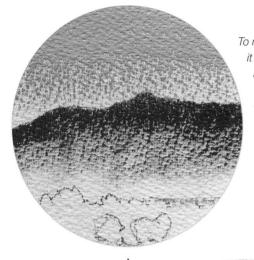

To make a gradation in the sky it is necessary to work quickly, accumulating more paint in the upper area of the paper.

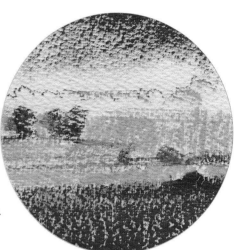

Wide horizontal brushstrokes of green and brown will cover the fields. The dry brush can barely indicate any details.

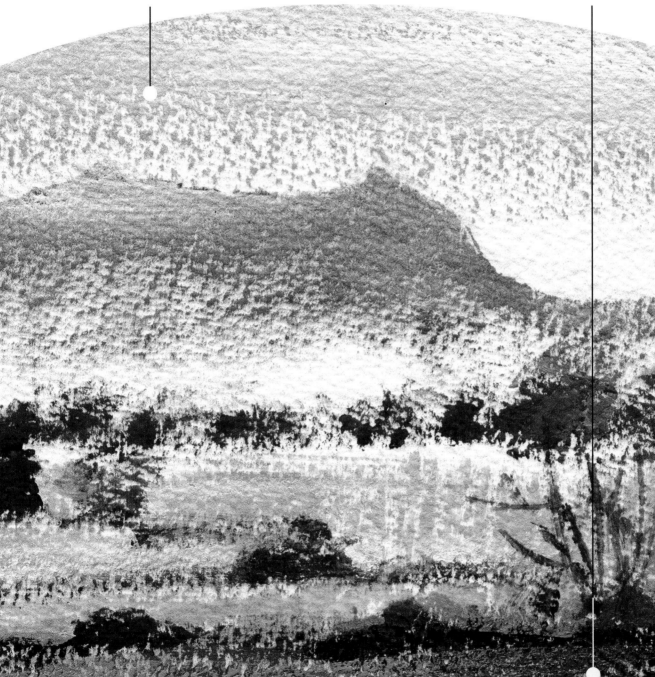

Collage
and Acrylics

Acrylic paint and fixatives are adhesive materials, ideal for collage and working with mixed media. Rags and papers are easy to glue on and they can be used as flat planes, or wrinkled and crumpled to make rough, irregular textures.

AN ADHESIVE PAINT
Acrylic paints and mediums are strongly adhesive, and able to keep heavy objects glued to the support. However, most artists prefer to adhere paper and fabric cutouts with white glue or latex instead of wasting paint. Therefore, it is best to first glue the pieces of paper to the support, wait for them to dry, and then cover them with paint.

COLLAGE WITH DIVERSE TEXTURES
If you are going to combine the collage with acrylics you should not settle for just one kind of paper or rag; try to combine several of them with diverse colors and textures. You also have the option of gluing folded or torn paper to the support, which will make a more interesting texture to work on. Then you can paint over them to integrate the texture with the paint. In some parts of the composition you can use crepe paper to create additional wrinkles or glazes.

Before beginning to paint with acrylics, glue the paper cutouts to the support with white glue or latex.

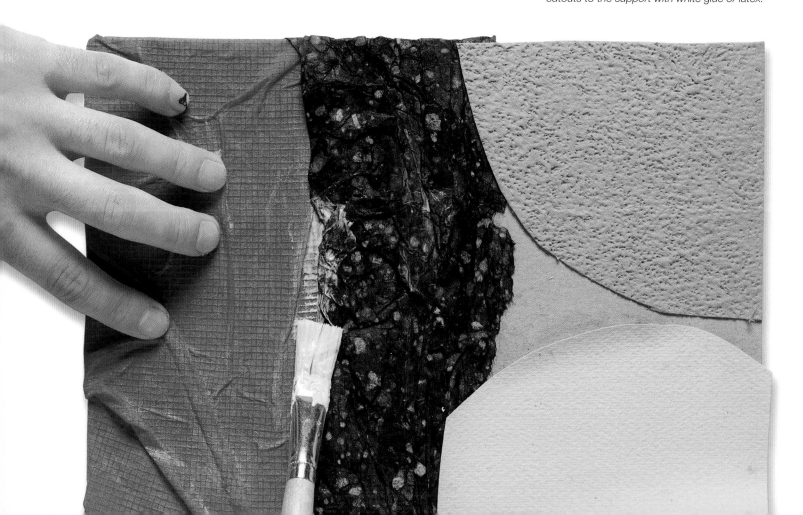

Wrinkled crepe paper makes a very interesting surface texture and an ideal base for painting.

Two papers prepared for collage. In this example you can see the artist's preparatory work.

CONTEMPORARY TECHNIQUES

Here are some examples of acrylic paintings, made on a base of glued paper using a layering technique, gluing fragments of colored paper with acrylic medium, and then more paper and paint. Over this colored base that is a collage are brushstrokes of acrylic paint. The graphic contrast between the brushwork and the background of the painting creates a very attractive surface.

Using colored paper collage painted over with acrylic paint, it is possible to create rich and beautiful compositions.

The origin of this technique is the papiers collés (glued paper) of the Cubists. It consisted of simple pieces of paper with flat colors that were glued to the paintings to increase the effects of the color. These first impressions of color will be finished with additions of acrylic paint.

Painting on Colored Paper

A VERY ATTRACTIVE AND CONTEMPORARY TECHNIQUE

The artists that worked in collage replaced rich materials and historical and academic themes with everyday subjects and plain materials, cutting and gluing disparate images that depicted the fragmented nature of urban life in the 20th century. The still life became the preferred subject for lovers of collage. Today the still life continues to be their main source of inspiration because of its color and simplicity, which is why we recommend starting with a couple of simple compositions made by joining a few plain objects on a table. The exercises that we show here are for those who are interested in learning about and working with the expressive possibilities of collage and its use as a tool for the creative production of images that will later be painted with acrylics.

1. First we choose paper of different colors that will work for a colorist representation of the real model. The papers are cut with scissors, and before gluing them they are placed on the support like a puzzle to check the arrangement.

2. The papers are glued to the support with latex. We cover the spaces that remain white with red acrylic paint on the table and a sienna wash on the background, over which we add some brushstrokes of thick white paint.

3. We darken the brown background with a wash of ochre. The teapot is finished with black. When it has dried we add some white dots. Finally, we add several lines on the table with a fine round brush.

1. We take three different round paper cutouts to compose the still life. The shapes do not have to be too symmetrical. The collage is essentially an experimental technique, so there are no strict rules to follow.

1

2

2. The composition is finished with a new piece of red paper. Now the painting begins. The background between the supposed vases is filled in with thick black paint. A yellow lemon is then added.

3. After shading the lemon with a green line the purely decorative phase begins. The plant forms adorning the vase on the left are made with a fine round brush and black paint. The interpretation is very modern and close to abstraction.

3

Once you have taken on small collage challenges you can attempt more complex and intricate themes, like landscapes, cityscapes, figures, etc.

Reserves with Acrylics

When you paint with acrylics you can run into a problem of having to represent a very light area with respect to the background, often with much detail. One solution is painting the background color, and when arriving at the light areas paint around them very carefully. But this is a lot of work. It is best to make use of reserves or a variation of them.

RESERVES WITH WAX

A reserve protects areas of the support so that they are not covered with paint. For example, wax reserves are based on the incompatibility of oil and water. Wax keeps the paint from covering certain parts of the composition. This method is very simple: scribble with a crayon on a clean

sheet of paper; then apply a layer of liquid acrylic. The paint will be repelled by the wax, leaving lightly spotted zones of white.

RESERVES WITH MASKING TAPE

If you want a totally clean outline or to make a perfectly straight line, it is best to use masking tape for the reserves. The straight edge of the tape helps you make straight lines, but you can also fold or wrinkle it to make curved and irregular outlines. The paint should not be too diluted, because it could seep under the tape and ruin the effect. You must be sure to attach the tape well to the support without leaving folds that are not adhered, and wait until the paint is dry before removing the tape.

Abstract painters that work with hard edges and clear divisions between shapes usually make reserves with masking tape to create sharp lines.

You can fold and wrinkle the masking tape to make a particular shape. You must be sure that it is completely adhered to the paper so that the paint does not flow under the folds.

MASKING FLUID

This substance is derived from latex, and is available in art supply stores in bottles. It is applied with a clean paint brush in dabs, or a motif can be drawn on the paper with just the fluid. Immediately after use the brush should be washed with soap and water to eliminate the gummy fluid before it dries. Then it is painted over with acrylic washes. When the support is dry the mask can be removed with a clean rubber eraser. It will come off easily and reveal the original white of the support. Here we demonstrate the graphic possibilities of the reserve.

Reserves made with masking fluid, tape, or wax work well for making patterns or very ornamental designs.

1. The initial drawing is made with masking fluid. We shake the bottle well before use, then draw the face with a fine round brush. We allow the fluid to dry and apply color washes over the paper.

2. After the paint is dry we remove the mask with an eraser to expose the original white surface.

3. The initial design is complemented with washes and thicker paint. To the right we incorporated a new decorative design also made with the masking fluid.

Oil pastels can also be combined with acrylics like wax crayons to create reserves that will repel acrylic paint. Furthermore, considering the variety of colors available in oil pastels, the results will be more colorful and gratifying. Therefore, if you make a drawing with oil pastels, using different bright colors, they will repel the acrylic paint when they are covered with washes and retain their independence and original bright colors. The paint must always be diluted because if it is too thick it can completely cover the crayon.

The initial drawing is made with a combination of different wax colors. They are applied with force so the lines will stand out and to cover the paper well.

Experiments with Oil Pastels

THE TEXTURE OF REJECTION

After you have tried the effects of acrylic paint over oil pastels, you can use them to try new textures and color combinations with any paint. To do the following simple exercise you can start with any landscape. The preliminary drawing will be done with oil pastels. Then you can apply an acrylic wash to cover the background. Washes of the green and blue from the landscape are then added over the crayon lines, and the refusal of the two media to mix causes very interesting textures and effects. More lines can be made with the wax crayons over the dry acrylic washes, which can be covered with new washes to complete the expressionist approach to the painting.

When covering the bushes with green washes the wax repels them. The green wash covers neither the blue lines nor the yellow shading. The wax marks add interest to the green wash.

Parallel lines of blue and orange crayon are made on the roof of the church. Again, the wash does not cover the lines because the two media are incompatible and repel each other.

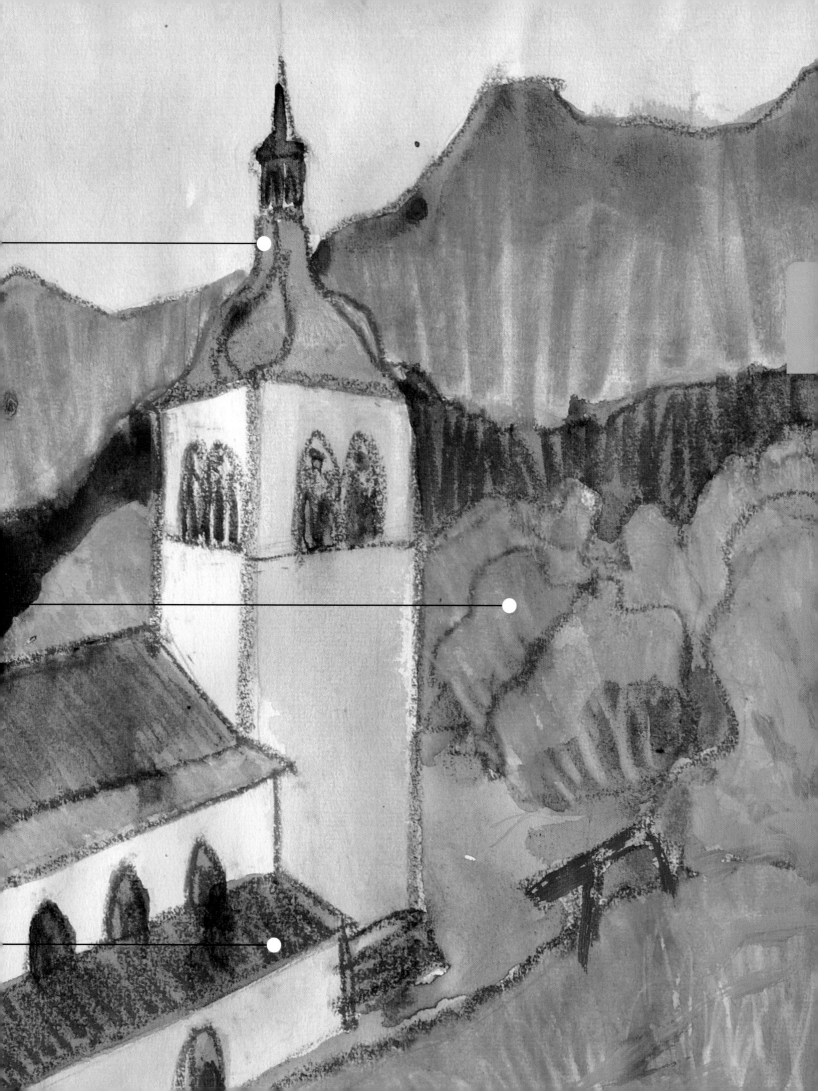

The Stencil, Reserving with Templates

This technique basically consists of cutting a stencil in cardboard or acetate and trying to reproduce an image on the surface of the painting with well-defined edges. If you wish to repeat the shapes just paint over the open parts of the template again. The point of making the stencil is to add a modern touch to your paintings.

PAINTING WITH A STENCIL

The stencil is a type of reserve. A stencil is used to paint on the support using a template where certain parts have been cut out for applying the paint through a few areas of the stenciled image. In its simplest form it is a matter of cutting a shape in cardboard, acetate, or a waxed paper, putting it on the support, and applying paint to it through the open areas. This way of working is very useful and can be combined with other techniques.

MAKING A STENCIL

You can purchase templates already made, choosing from an endless selection, or you can make them yourself with cardboard or acetate. Draw a model on the cardboard and cut out the areas you wish to paint using a craft knife or scissors. It will look like an open space with solid areas around it.

The stencils should be washed well after use, since they can only be used for a short time before the paint begins to filter through them.

To make a stencil you first make a drawing on the cardboard and then cut each part with a craft knife.

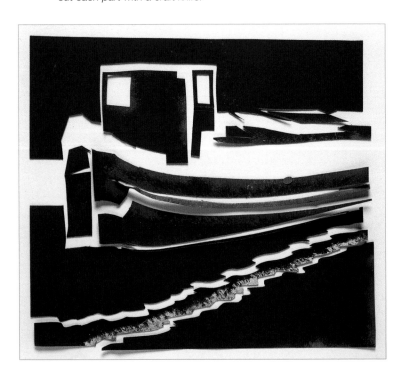

The design of the stencil should be simple, with edges that are straight and not too irregular. When it is finished you can put the pieces together to check the way it looks.

TAPPING WITH A BRUSH

To paint with a stencil you need a stiff brush, preferably with short and even bristles. You can buy them in art supply shops, craft stores, and even hardware stores. Carefully wet the bristles with paint because you have to paint lightly. Remove the excess on a separate piece of absorbent paper. Then hold the stencil with one hand so it does not move at all, and with the other hand paint by tapping the brush on the stencil.

If you are going to use stencils often, it is a good idea to have a brush for each color, because if you clean off the paint to use the brush with another color, you will have to wait for the bristles to dry completely.

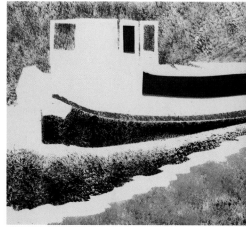

After the stencils have been used do not throw them away; they can be used again. Clean them and keep them in a folder or an envelope.

1. We recommend starting to paint around the edges and then paint the inside of the window. The brush should be dry each time it is used.

2. The brush marks should be dry. It is not necessary to fill up the entire window or that the color be uniform. Gradations of various overlaid colors can even be made.

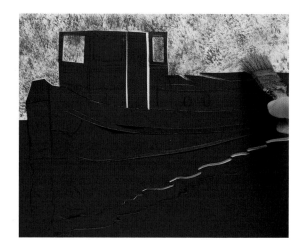

3. After doing the stenciling, remove the template slowly so you do not smear the edges. Working with paint in layers requires removing the stencil carefully before the paint dries; if not the edges can stick.

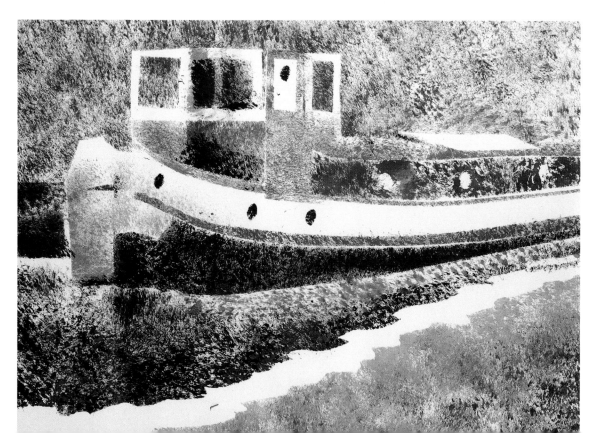

Spattering Paint

To spatter, the toothbrush is held near the support, always in a horizontal position. Scrape the bristles with a thumbnail to spray the paint.

Splashing or spattering paint on the support is a very effective manner of suggesting certain textures, but it is also a technique used to animate and add interest to large areas of flat color. Painters of landscapes and cityscapes sometimes use spattering to represent the broken surfaces of vegetation or the tactile qualities of construction materials. An old toothbrush is a very useful tool for spattering. The bristles are dipped in fairly thick paint and then they are scraped with the thumbnail while holding the toothbrush horizontal to the picture plane, covering it with a spray of tiny droplets. Another way to spatter consists of soaking a thick brush with paint and lightly tapping it against an extended finger or the handle of another brush. This produces a slightly denser spatter with larger drops of paint. If you prefer a very light spatter on a large surface, you can use a plant sprayer.

USING STENCILS

This is another good example of the importance of stencils in acrylic painting. If you wish to avoid painting certain areas you can cover any zone with paper or acetate, since spattering is difficult to control and tends to fall where it is not wanted. Cutout stencils will help you control the appearance of the model, since spattering cannot be used to represent shapes with well-defined edges unless you place limits like pieces of cardboard that act as stencils.

The painting is constructed in phases. The stencils cover or reserve areas that are not to be painted that color, and they are used progressively. It is a bit like constructing the painting in parts, like the pieces of a puzzle.

The stencil plays an important role in the spattering process, keeping the paint from covering areas that we wish to preserve.

The Plasticity of

GABRIEL MARTÍN. STILL LIFE WITH PEARS, 2007.
ACRYLICS ON SAND AND GRAVEL

the Mass

Acrylics are already quite thick,

with enough consistency to create volume; however, they have the advantage of mixing easily with other substances to alter their composition, their viscosity, and to gain even more volume. They become, in a way, an adhesive substance that upon drying forms a thin plastic film. This allows them to create a wide range of textures, unequaled by any other painting medium. In the following section we point out some approaches and effects related to the creation of relief using acrylic paint.

Squirted Paint

Acrylic paint has very strong plastic qualities that allow it to be used in a way that is not possible with other more traditional media. One of these techniques is squirting it directly on the support through a spout specifically sold for attaching to bottles of acrylic paint. Painting by squirting requires knowing how to precisely control the quantity of paint that is used and to control and use it with fluidity.

BOTTLES WITH SPOUTS

Bottles equipped with spouts for squirting are necessary for working with this technique. Cut the tip of the spout with a craft knife, keeping in mind that the height of the cut on the spout will determine the thickness of the bead of paint. It is best to begin with a small cut and later make another if you need a larger opening. It is good to work with a wide range of colors since this approach does not allow much mixing of the paint. Colors can also be used straight from the tube, although only occasionally, for the purpose of making thick impasto lines.

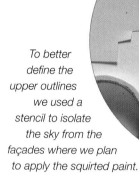

To better define the upper outlines we used a stencil to isolate the sky from the façades where we plan to apply the squirted paint.

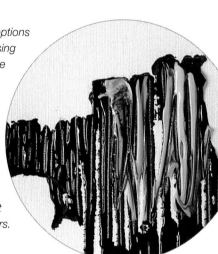

We have two options when superimposing paint: allowing the first application to dry so the colors do not mix, or mixing the two colors while they are wet. The second option will result in somewhat muddy colors.

We do not wait for the paint to dry to remove the stencil because it can stick to the support.

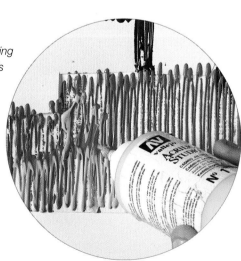

The squirting technique is simple. Make up and down movements with the bottle while squeezing it to create a flowing line without gaps or interruptions.

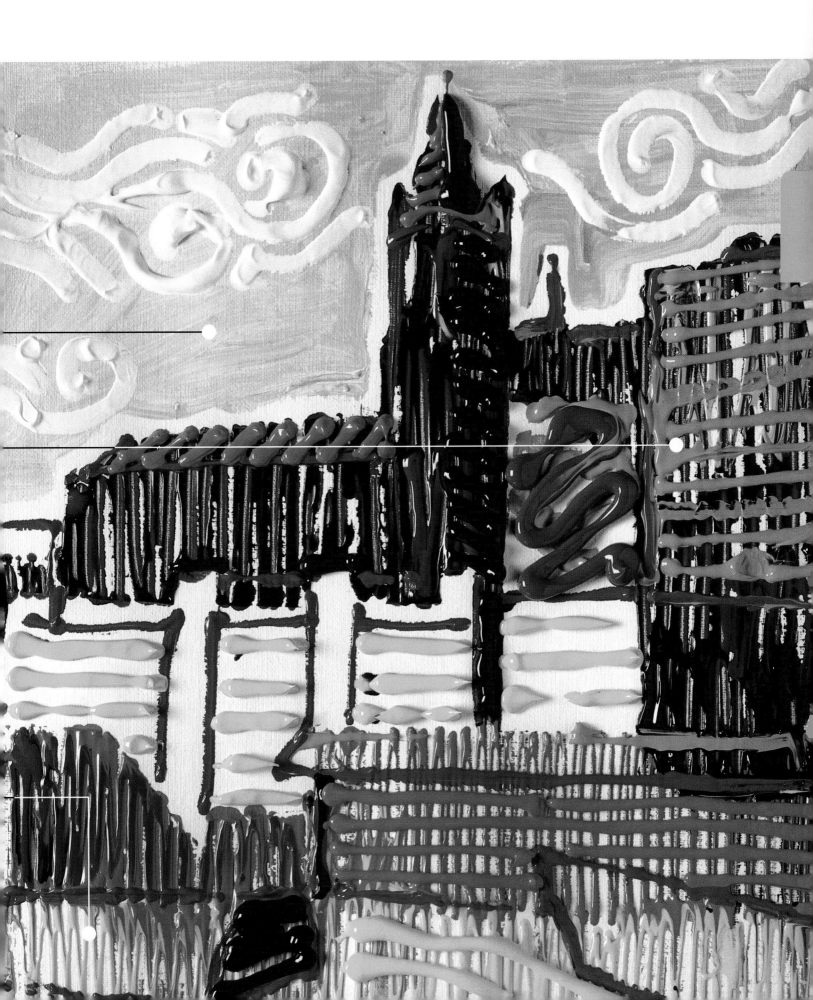

Small Glossary of Textures

Acrylics have no competition when it comes to creating textures with astonishing results. There are few limitations. Since they are strongly adhesive there are many materials that can be coated with or adhered to the paint, and there are many effects that we can create on the surface when it is still wet. The only danger with textures is using them to the extreme. Instead of adding visual interest, each texture can end up overpowering the impact of the image next to it.

DISCOVER AND EXPERIMENT

It is good to experiment and develop some creative textures to give yourself more possible approaches making paintings. We offer a visual glossary for testing and adapting these new approaches. You will have fun discovering the effects of textures created with acrylic mediums before putting them to work in a real painting. Experiment with new effects, combinations, and strange materials that you can incorporate into acrylics to make richly textured surfaces with more volume. A creative texture can include practically anything.

Very diluted paint applied over a mass created with gesso.

This texture created with gesso was painted over with thick opaque paint.

Gesso with sgraffito, that is, long grooves made with the point of a spatula. The diluted color was applied after the paste dried.

Gesso with small regular grooves made with the tip of a round spatula. Diluted color was added after drying.

Drops of melted wax on scrap cardboard. Fluid red paint was applied over the wax, which resisted the paint leaving the drops lighter in color.

Polka dot effect made with tubes of acrylic paint. Each color dot is a large mass with a characteristic point on top.

Acrylic gel mixed with grains of rice. After the surface dried we painted it with thick brown paint.

Acrylic gel mixed with small noodles. We painted it with thick green paint, and after it dried we painted the raised areas with thick orange paint.

Crepe paper glued with latex and forming random wrinkles. It was painted with a green wash; then we brushed thick red paint over it.

Gel mixed with sand and tiny stones. We painted the dry texture with a creamy opaque blue, and then the high areas with orange.

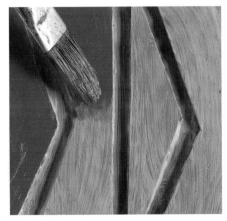

This relief was created by collage, gluing pieces of cardboard with latex to give us a new base to paint.

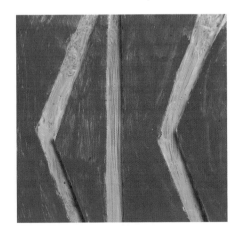

Bas-relief with pieces of cardboard painted with thick yellow and red.

Gluing Materials and Objects:
Collage in Relief

Paint, like any of the gels and acrylic mediums, has excellent adhesive properties. Therefore, it can also be used as very effective glue for attaching materials and objects to the surface of a painting. Collage with materials can be satisfying and gives us the opportunity of contemplating the creative potential of each material.

ANYTHING WILL WORK
Colored papers, tissue, aluminum foil, magazine clippings, fabric, leaves, stones, cork, plastic objects, or aged wood can be encrusted in a layer of fresh acrylic paint, on modeling paste, or gesso. However, the best option is to first glue the object with latex or white glue and wait for it to dry to guarantee a strong bond. Then, it is a good idea to cover all the materials with a mixture of one half latex and one half gesso. This will act as a white primer that covers all surfaces and makes them the same. Acrylics can be painted over any of the surfaces, and the primer will guarantee better adhesion and that the colors maintain their purity, intensity, and brightness.

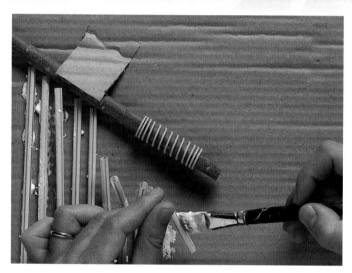

1. Acrylic paint is a good adhesive, but it is better to glue the objects to the cardboard support with latex.

2. When the glue has dried all the surfaces can be "equalized" with white primer made from half latex and half gesso.

1

2

Any objects can be glued to the support; you only need to be creative and arrange them tastefully.

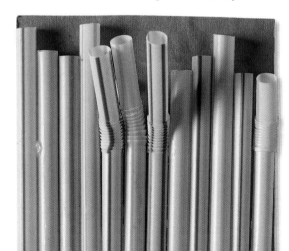

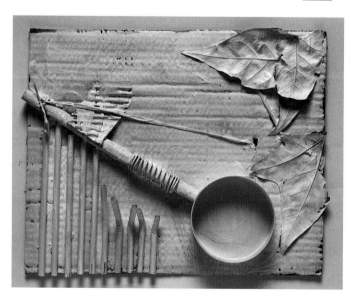

3

COLLAGE WITH FOUND OBJECTS

We finish the lesson with a simple exercise. It consists of collecting several common objects that are at hand and composing an abstract painting with them. We can make use of the lid of a jar, a stick, a piece of branch, an electric cable, drinking straws, and a couple of leaves. We place them on a piece of cardboard to form a harmonious composition. When the arrangement is to our liking we glue them to the support with latex. After the glue is dry we cover the entire surface with the mixture of gesso and latex. The acrylics adhere better and are brighter on this layer of white. Now all we have to do is paint, highlighting each element with a medium thick paint.

You can construct an interesting surface with just a few elements. Working with acrylics will create an interpretation that looks like many contemporary paintings.

3. Now is the moment to paint with thick opaque colors. Any tones can be used, depending on the preferences of the artist.

4. The finished exercise is an abstract composition whose main significance is the interaction of the colors with the volume of the objects. This is a piece of contemporary art.

4

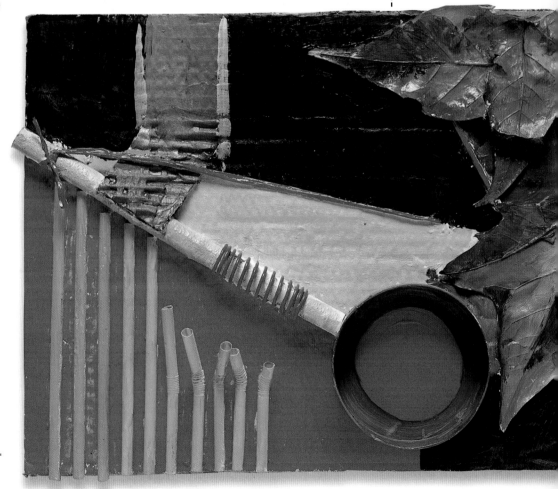

Step

by Step

"THE PAINTER TRANSFORMS THE CONCEPT OF HIS EXPERIENCE INTO A WORK OF ART. THERE ARE NO FIXED RULES FOR THIS. THE RULES FOR AN INDIVIDUAL WORK OF ART ARE CREATED DURING THE WORK AND THROUGH THE PERSONALITY OF THE CREATOR, HIS TECHNIQUE, AND THE HIS GOAL…"

Emil Nolde, Jahre der Kämpfe, Christian Wolf Verlag, Flensburg, 1956.

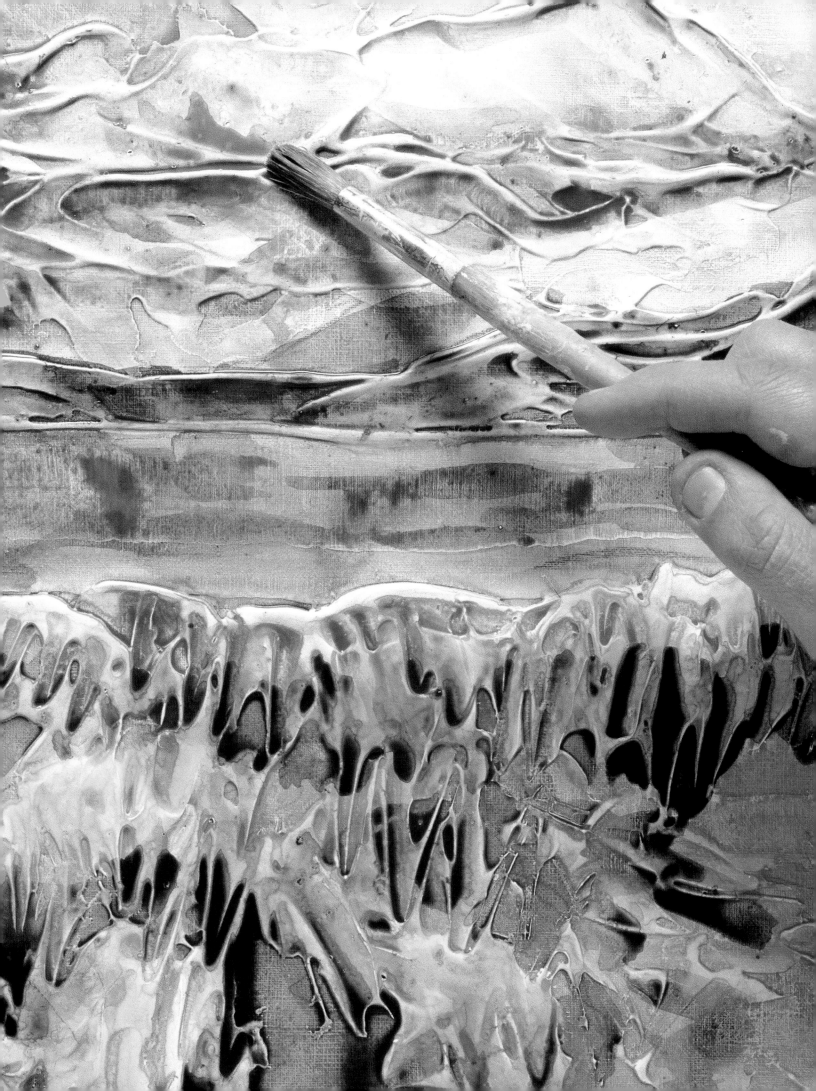

Painting with Acrylics

We begin the exercises with a simple model, which is compact and does not present too much of a challenge to draw. This particular exercise should be considered a guide for learning the best way of painting, that is, of making the first applications of acrylic paint. This step-by-step exercise by Gabriel Martín will be especially useful if you are accustomed to painting with oils since the working method is quite different.

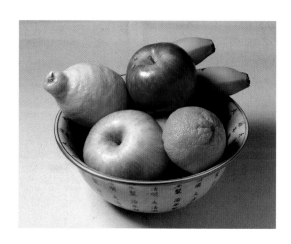

1

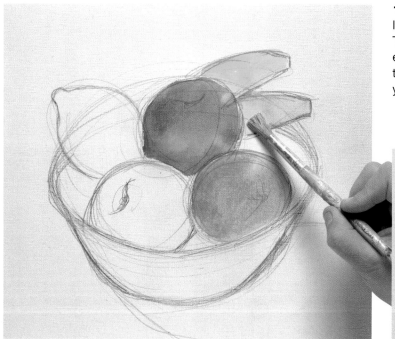

1. The project begins with a very simple line drawing, without shading or details. The colors are very diluted with water, elementary and general, that is, red on the apple, orange on the orange, and yellow on the bananas.

2

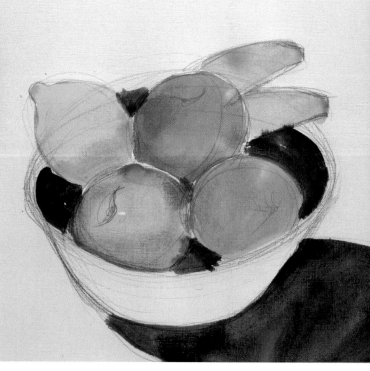

2. The first application of diluted acrylic approximately corresponds to the colors of each element. On the lemon and the apple at the left he makes use of the dampness of the paper to mix a second color, which is also diluted. Do not worry if your resulting colors are not exactly the same as the ones used here.

3

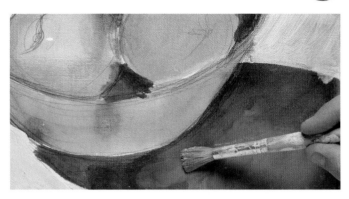

3. The artist paints the background with ochre in the upper area and thicker white below. A wash of intense Payne's gray or diluted black is used for the shadows of the fruit bowl. They are diluted, flat, and with little gradation at first.

4. After waiting for the paint to dry he then repaints each element with denser and more opaque color. The lemon is finished with three shades of yellow. The brushstrokes are wide with little detail. The apple has the same treatment, sketchy and stylized.

If you do not have enough skill with the brush, and with each stroke you miss the shapes of the elements, you can use a fine round brush to draw the outlines.

4

5

5. The artist uses the same kind of wide dense brushstroke for the rest of the fruit, allowing some of the color from previous layers to show through. The bananas have been simply constructed with a few short brushstrokes of three colors, yellow, yellow green, and khaki green.

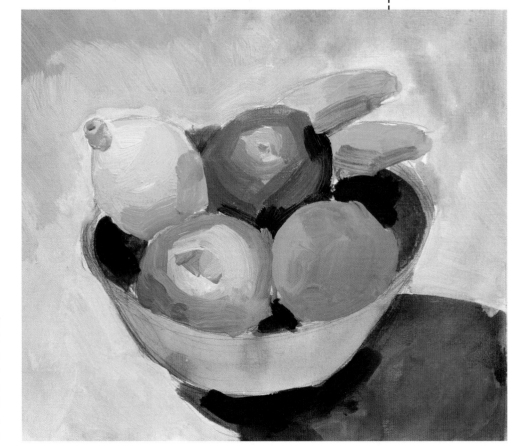

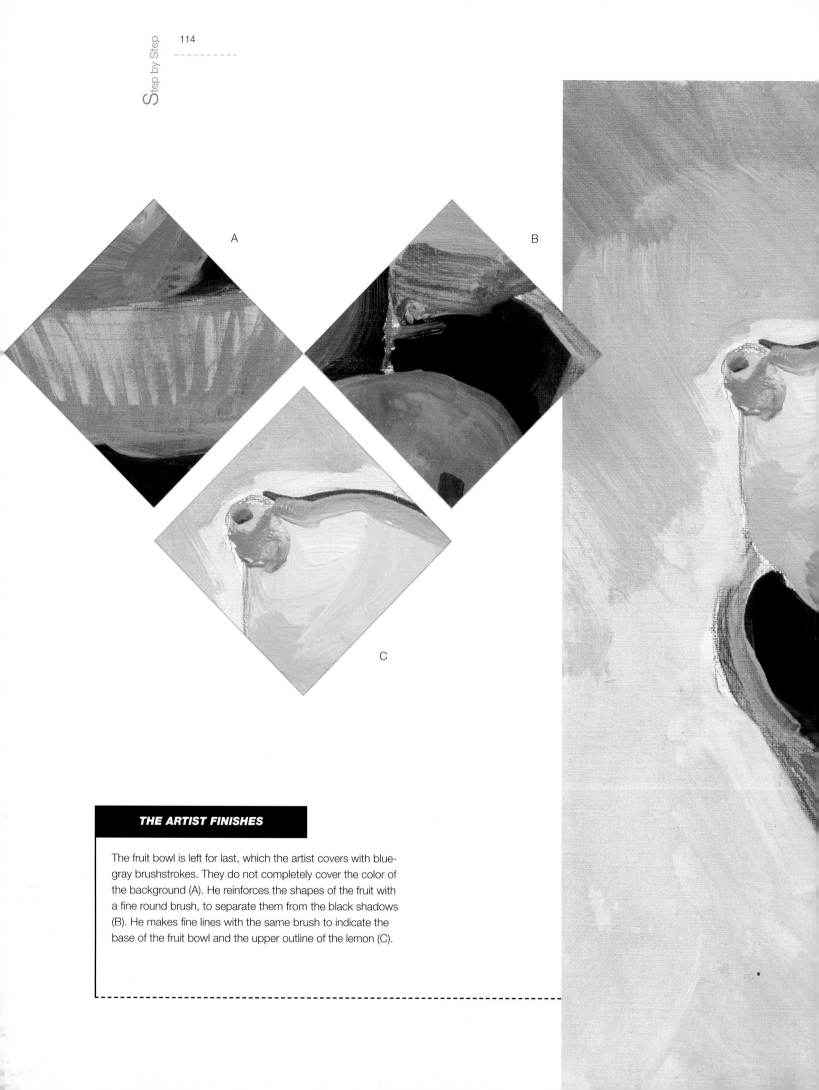

A

B

C

THE ARTIST FINISHES

The fruit bowl is left for last, which the artist covers with blue-gray brushstrokes. They do not completely cover the color of the background (A). He reinforces the shapes of the fruit with a fine round brush, to separate them from the black shadows (B). He makes fine lines with the same brush to indicate the base of the fruit bowl and the upper outline of the lemon (C).

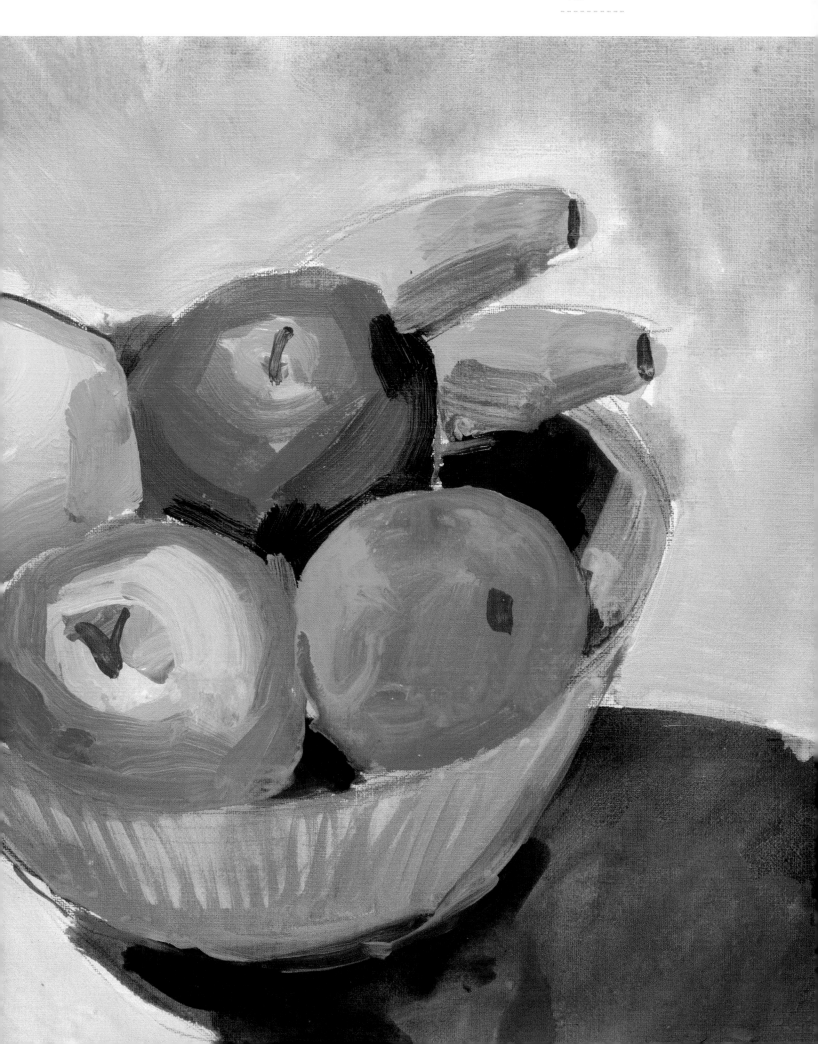

Pumpkins on a Colored Background

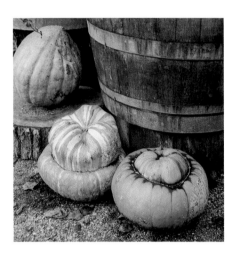

The second exercise is also simple and without flourishes. Painting a still life consisting of a few pumpkins on a dark painted background is a good excuse for working with opaque acrylics and learning to leave some areas unpainted, allowing the background color to show through. Working on a pre-painted support makes it easier to work with the middle tones and lighter colors, which thanks to the contrast, look more luminous. Gabriel Martín, who also did this exercise, shows us how to proceed.

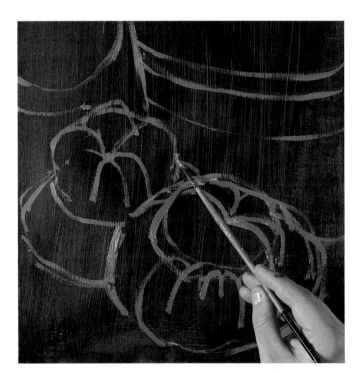

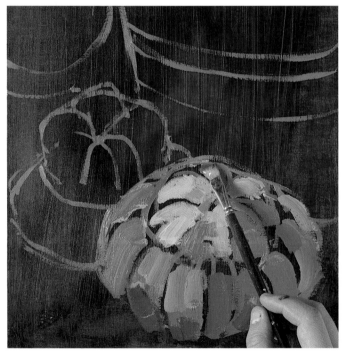

1. It is common to choose browns or blues as the background color. The paint is applied with a thick, wide brush. When it is dry the subject is sketched directly in orange with a fine, round brush. If you feel confident drawing, you can make a preliminary pencil drawing.

2. The pumpkin in the foreground is painted with shades of orange. Some touches of yellow are applied in the lightest areas and carmine in the darkest. The paint should never be diluted; it is better to preserve the thick and opaque consistency of the paint as it comes from the tube.

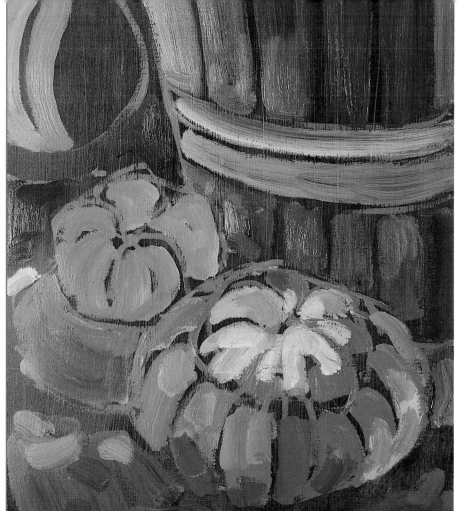

The important part of painting on a colored background is letting it show through. Avoid completely covering the lines that define the silhouette of the pumpkin. The blue lines add solidity and shape.

3

3. The same range of oranges is used to complete the other pumpkin. To increase the contrast between the pumpkins and the background, the barrel and the third pumpkin that is somewhat farther back are painted with dominant greens and blues. This way the dark areas seem more illuminated and colorful, and much more attractive.

4. The background is painted in a similar manner, leaving space where it shows through the painted areas. On the barrel the first red becomes an interesting counterpoint to the green since the two colors are complementary. The brush is fully loaded with paint to make sure that each brushstroke completely colors the intense blue in the background.

4

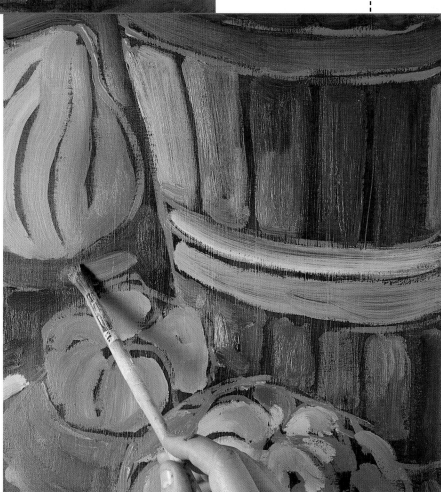

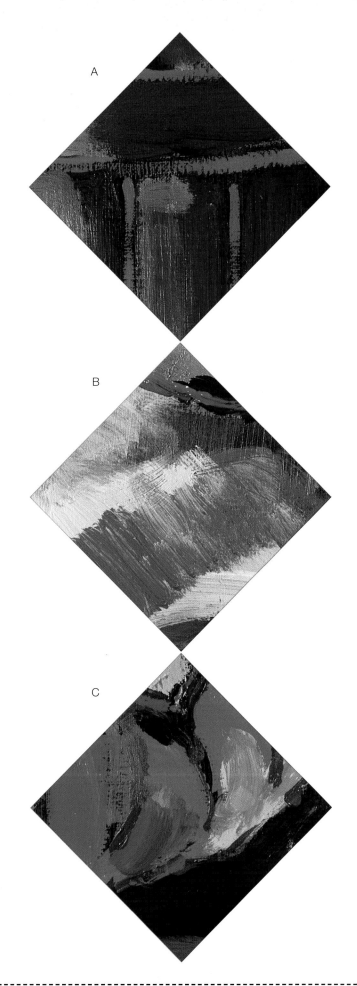

A

B

C

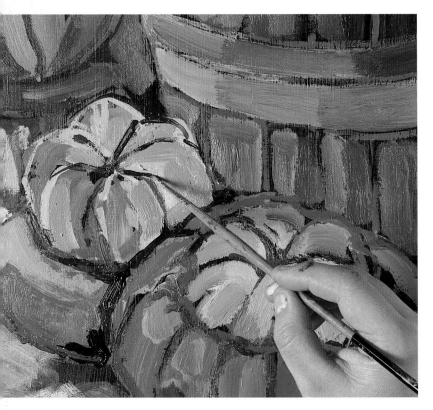

5. After completing the painting, that is to say, covering each area with orange or green paint, the artist returns to the line, the outlines of the objects, which have become lost as he painted. He adds lines with a fine round brush, the interior and exterior lines of the objects, on the whole group of pumpkins.

5

THE ARTIST FINISHES

The final touches consist of increasing the contrast between the complements, between the red and greens of the barrel. This is done by painting over the initial red lines (A). The bluish brushstrokes on the floor seem more clearly differentiated to add more energy and express the different grades of light (B). The green in the background spills into the shadows of the pumpkin. Some of the linear shapes and contrasting shadows on the pumpkins are also resolved with this color (C).

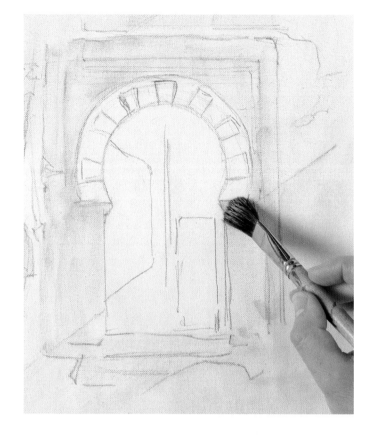

1

Dry Brush Technique

Now we go to an architectural theme to explain the technique of working with dry brush, using just a little paint that is not diluted with water. This technique is very blurry and the paint is usually applied with a light scrubbing movement using a stiff brush. If you are working on canvas or canvas board, the grain is a big help because the paint is only deposited in the high areas of the texture. Watch how Óscar Sanchís depicts this subject that is not lacking color.

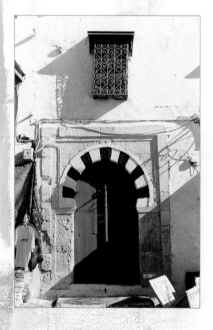

2

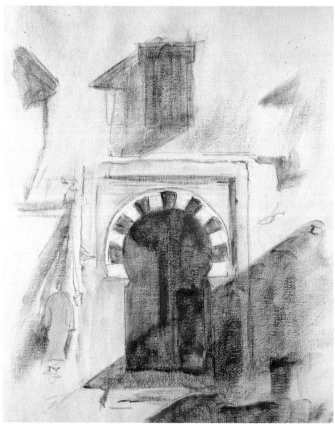

1. The architectural drawing should be simple, since the dry brush technique does not allow much detail. The first step is to break up the whiteness of the canvas by brushing it with a yellowish color, applied unevenly. This will add warmth to the façade.

2. The inside of the doorway is covered by light scrubbing with a bristle brush in a little ultramarine blue. The window and some projected shadows are painted using the same color, but even less paint. This produces an effect of blended and somewhat ephemeral colors.

3

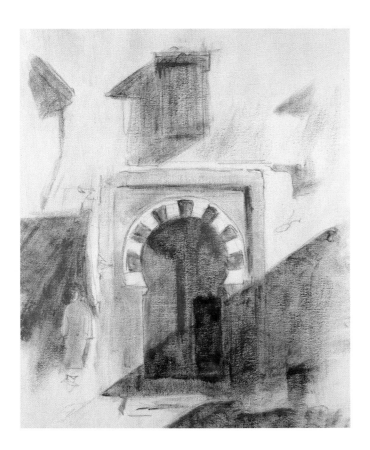

When painting architectural structures it is important that certain lines appear straight. A piece of cardboard or paper is used as a straight edge, the brush lightly sliding along the edge.

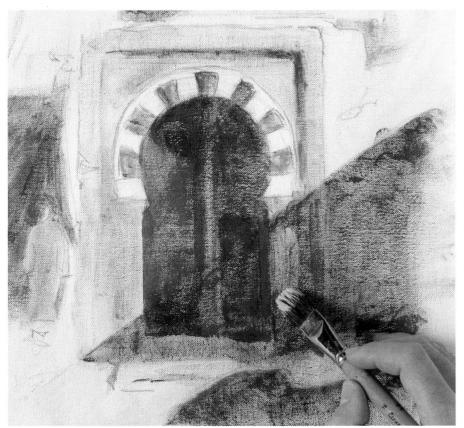

3. The shaded areas on the façade are darkened with carmine. Since acrylics dry quickly, the layers of paint can be overlaid without waiting. The mixture of carmine and blue create a violet shadow.

4. A larger charge of color is needed to paint the doorframe, since the acrylic ochre and yellow tones are very transparent. Carmine is used again to shade the inside of the door and also the awning at the left. The same color outlines and darkens the shadow of the screen in the window.

4

5

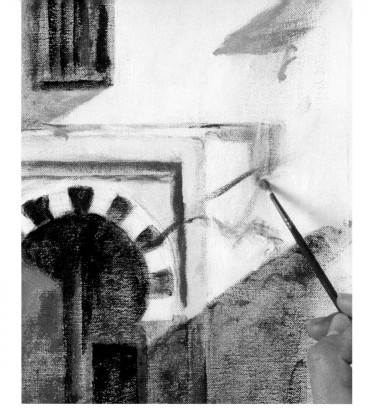

5. The painting is almost finished with large, loose brushstrokes, but detailed line work is needed to bring the representation into focus. Some details are highlighted with a fine round brush containing a bit more color, and areas of darker color are created around the door and the screened window.

A

B

C

THE ARTIST FINISHES

The advantage of working with dry brush is that the overlaid colors create an effect similar to glazing. The final result is very atmospheric and can be combined with a few strokes of denser color to some linear definition to the shapes (A). If you focus on the dark areas, the color never completely covers the white of the background (B). At the same time, the freshness of this technique allows you to leave some areas sketched but not finished (C).

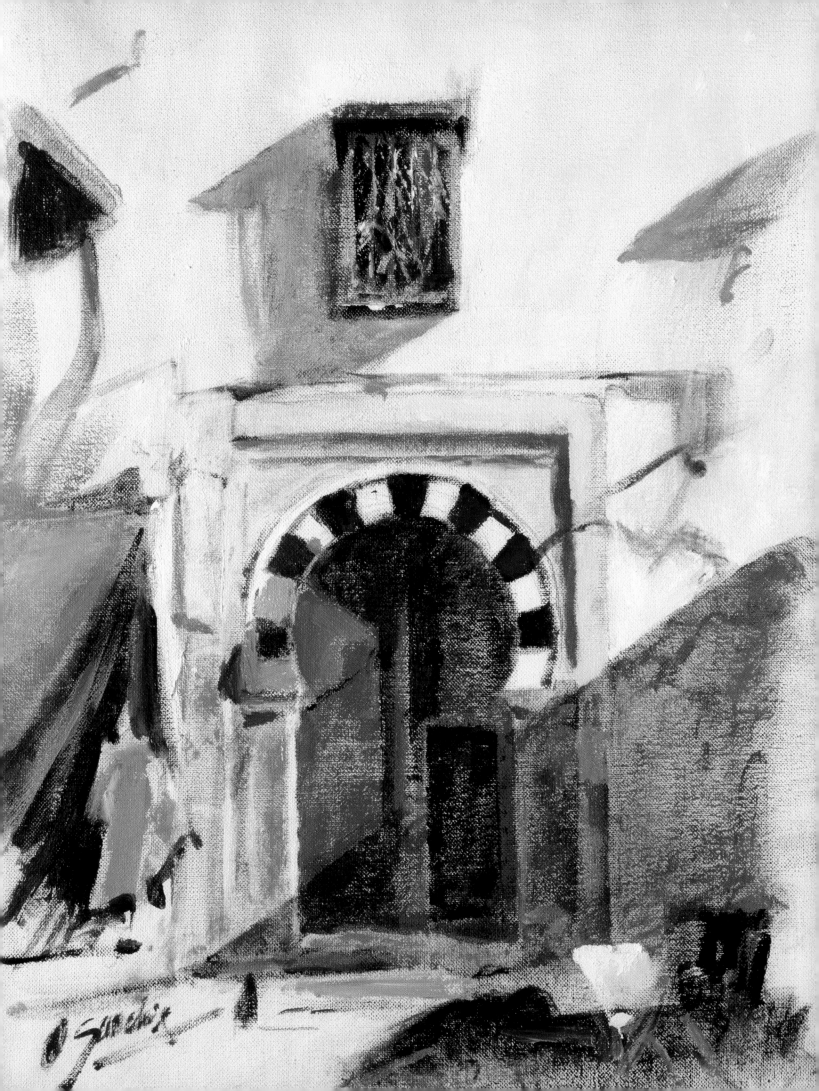

Fluid Brushstrokes

Here we include a brief exercise by Álex Sagarra to compare it with the previous one, which was constructed with a dry brush. In this case, a simple architectural motif was chosen to be depicted with thick and opaque brushstrokes. This is done by working with a greater amount of paint, slightly diluted with a little water.

1

2

3

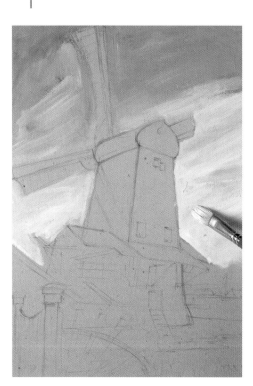

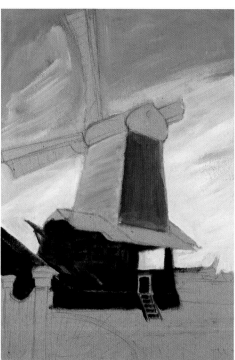

1. The composition is simple. To make a pencil drawing of the windmill you can look at it as a simple geometric shape. After the sketch the sky is painted with violet, pink, and white, blending the colors with each other while they are wet. If you use large or medium brushes you will keep the work from getting too complicated.

2. The body of the windmill is painted. The colors are simplified and the illuminated and shaded sides are painted in two tones of green. The fluidity of the paint lets you see

the direction of the artist's brushstrokes. The shaded space underneath is done with brown mixed with ultramarine blue.

3. The grass is painted with horizontal brushstrokes of medium green. It helps to mix a little brown and yellow to create different variations of green so that the grass does not look too even. The water in the background is finished with just two brushstrokes of bluish white and white.

4. The exercise is nearly finished. Now is the time to use smaller brushes to finish covering the smallest spaces and indicate some details. The wood blades of the windmill are painted with light violet, and the roof of the windmill with a darker violet. While the latter color is still wet a little white was added to the brightest area.

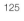

A

B

C

THE ARTIST FINISHES

The blades of the windmill are painted with three strokes of white and brown. Next, a grid is drawn with very thin lines (A). The fence in the foreground is finished with the same dark brown (B). You can use the brushstrokes to create the illusion of space. Here the short brushstrokes at the bottom give the impression of grass seen up close (C).

Color Glazes

1

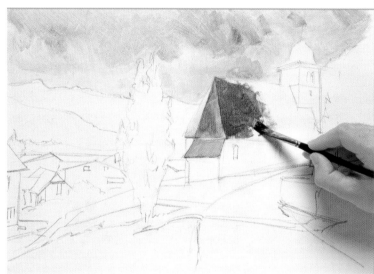

2

The artist Óscar Sanchís depicts this rural scene with acrylic glazes. Before beginning he had to consider two important factors. First, the background he was to work on had to be white. The effect produced by the technique of applying layers is very luminous because the white of the support can be seen through the colors. The other factor concerns the order in which the layers are applied. It is not necessary to follow tradition, which means starting with the farther planes and finishing with the nearest. The painting will be a little more random so that the still wet glazes do not touch each other. In order to make glazes it is not enough to just add water; a little transparent medium must be included in the diluting mixture to maintain the strength of the color.

1. The first application consists of putting a series of pale blues in the sky. This blue turns to yellow along the outline of the mountains. The layer of color should be very transparent so the sky will look bright.

2. The roof of the church is painted with three different violet tones mixed with a little brown. The artist tries not to touch the wash in the sky with the brush because it is still wet.

3. The tree on the right and the grass along the road are painted with brown mixed with ochre and a little light green, both diluted with water and gloss medium.

3

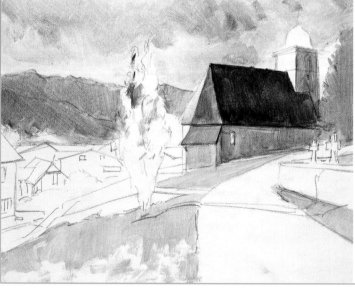

4

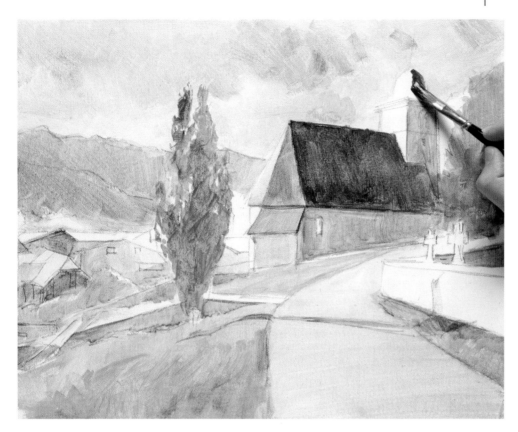

If you are going to work with glazes you must be very careful with the drawing, since it is very likely that the pencil lines will still be visible after the painting is finished.

5

4. The space occupied by the tree and the houses to the left is painted with a series of green, violet, and very light grays, diluted to represent the lightest tones of the area. Later it will be finished with darker colors. To paint shapes with hard edges, like the roof of the bell tower, you should wait until the first layers of color have dried. (The asphalt road is covered with a light red glaze.)

5. The first phase of the painting is allowed to dry completely. A brown wash is prepared and used to paint the dark foliage on the tree. Then the brown is mixed with violet for painting the shaded parts of the houses.

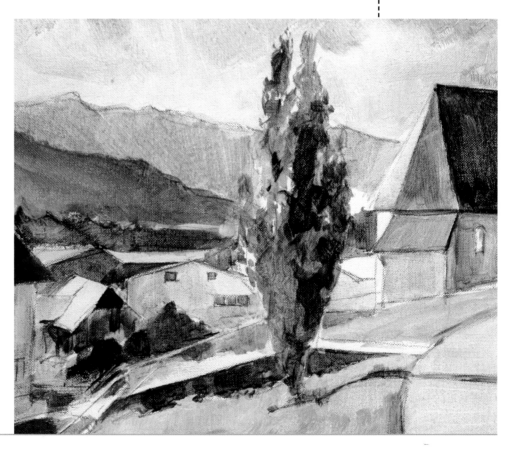

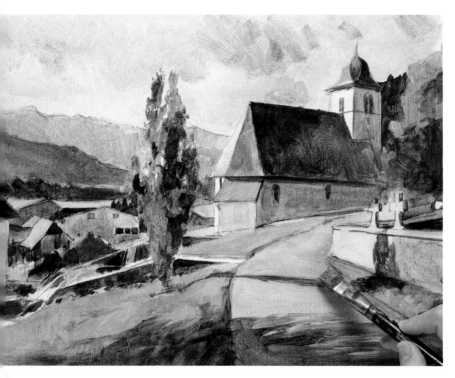

A

6. Now you must wait for the initial glazes to dry. At the right moment new glazes of transparent color are applied over the previous ones like this: the façade of the church is darkened with a brown glaze; an orange tone is created on the road by adding yellow; and the shadows in the foreground are added with violet.

THE ARTIST FINISHES

Near the end of the exercise the glazes are applied more carefully to the houses and the vegetation (A). The sky is intensified with a new blue glaze (B), creating contrasts with the clouds. The whites are made by leaving certain areas of the canvas unpainted (C).

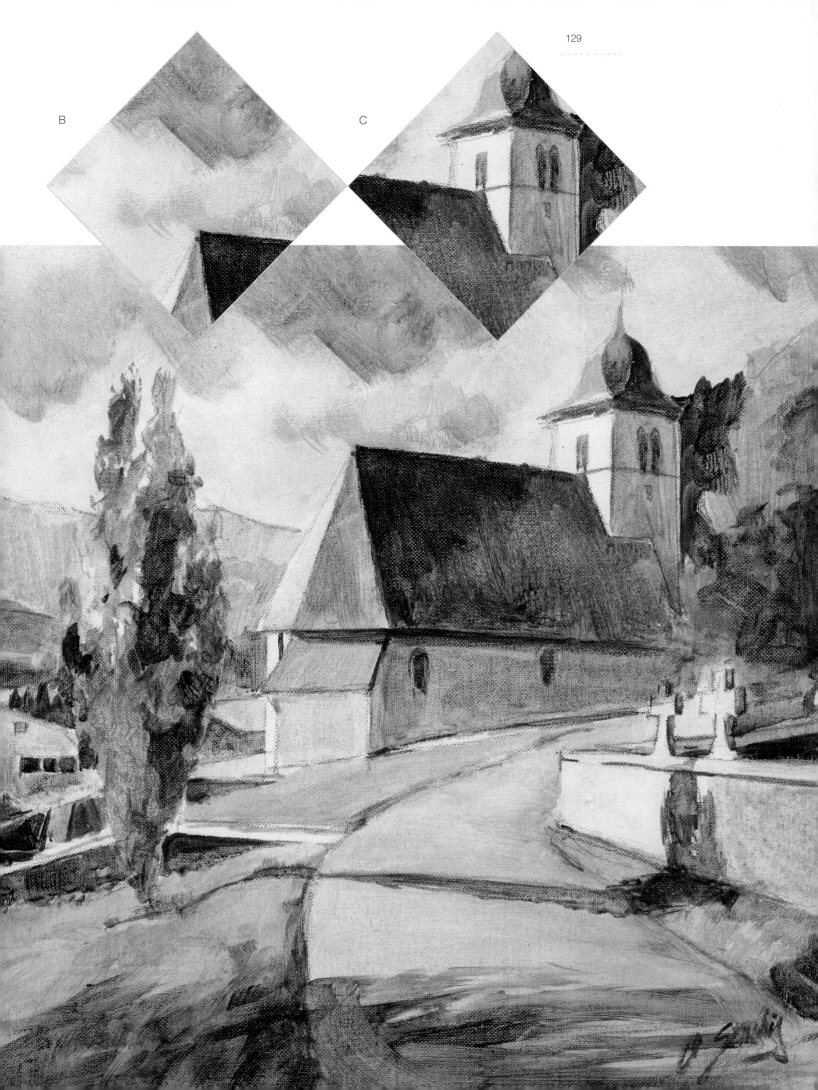

B

C

Glazing over Textures

W hat happens if acrylic glazes are applied on a textured surface? The answer is simple; the washes will try to settle in the low areas and grooves. This effect is clearly explained in this brief exercise by Gabriel Martín. Pay close attention; this is a technique that is almost unique to acrylic paint and very difficult to achieve with other media like gouache and oils.

1. The main features of the model in the photograph are reproduced in three dimensions, like a bas-relief sculpture. The shapes of the clouds, the mountains, and the nearby vegetation are created with spatula and gesso. The spatula marks should change direction to better describe the texture of each zone. The lake is perfectly smooth.

2. The gesso is allowed to dry for several hours, and it is even better not to begin painting until the next day. Each area is painted with washes of acrylic paint. Notice that the color is more intense in the hollows and lighter on the elevated areas of the relief. The main concern should be painting the largest surfaces with uniform washes. The relief and the uneven distribution of the washes will take care of creating a variety and diversity of values in each color.

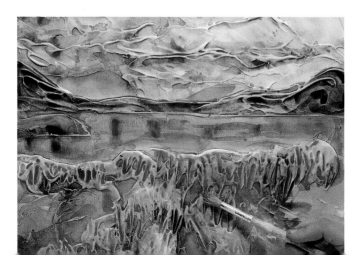

3. After the washes in the lower areas have dried a second color wash is applied. The process is the same, painting with diluted color and letting it collect in the low areas, although this time the washes will be smaller, more localized, and adding more colors to each zone.

THE ARTIST FINISHES

The exercise is finished after two or three glazes of different colors. The vegetation should be resolved with several glazes of warm colors that mix wet on wet (A). You want the washes on the sky to be light so the white of the gesso can be seen (B). The water can be painted with a monochrome wash; it is best not to work this area too much (C).

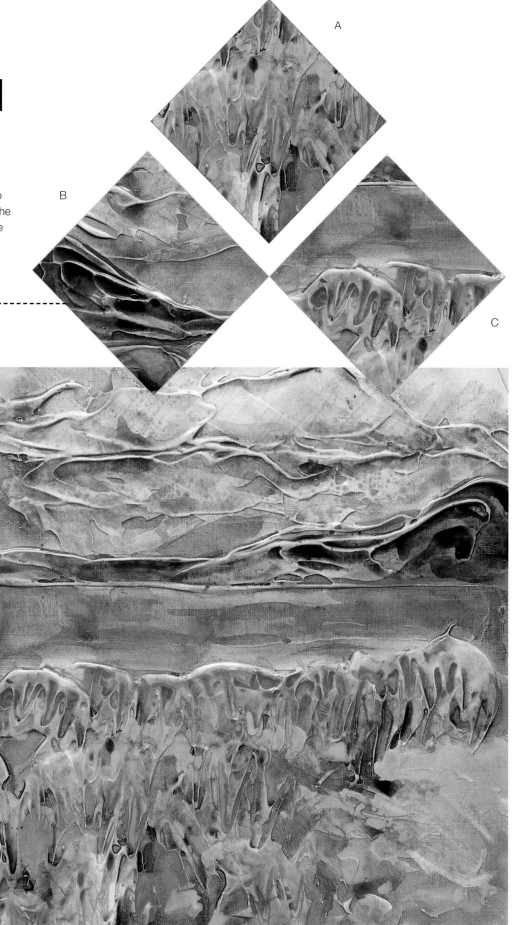

A

B

C

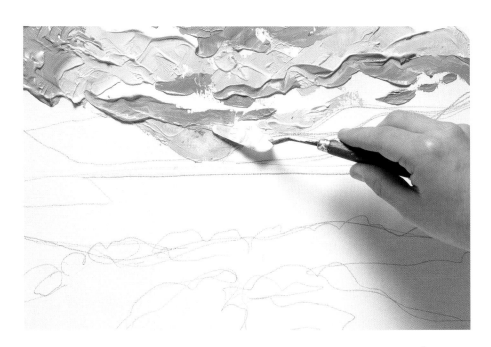

Using the same model as in the last exercise, Gabriel Martín painted a very different landscape with acrylics and a spatula. He did not use gesso to prepare a textured surface, but he occasionally used it as a medium or a filler to add volume and opacity to the acrylic paint. This gives the acrylics more consistency. Using the same model allows you to compare the final results, which have quite different surface qualities.

Painting a Landscape with a Spatula

1

2

1. This subject was deliberately chosen because it is simple; it is hardly necessary to make a drawing. The work begins by covering the sky with shades of violet using a medium spatula. The spatula should be dragged flat against the surface.

2. In the clouds pinks, violets, and white colors alternate; a little gesso was added to give them more volume. The outline of the farthest mountains was made with gray and ultramarine blue. The paint must be applied carefully, since too much manipulation will mix the colors.

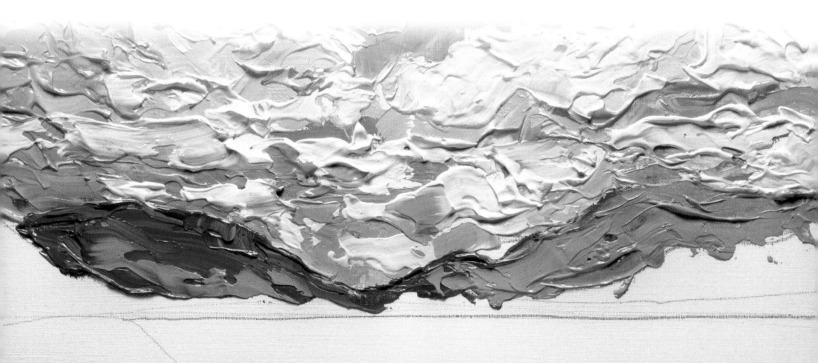

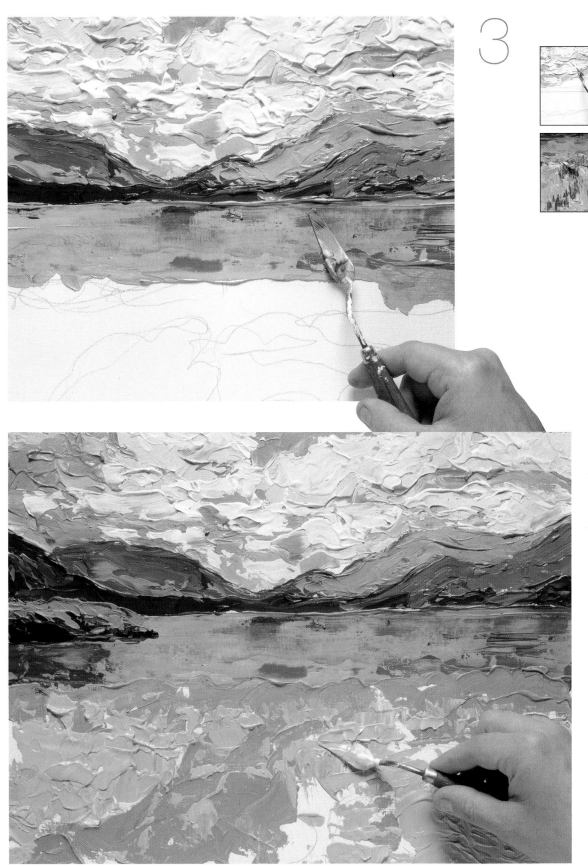

The secret to painting well with a spatula is in changing its position according to the type of application. The flat back of the blade is used for large areas of color, the edge for making lines, and the tip for small applications and textures.

3. The closest mountains should be a darker color than the farthest ones. The space for the lake is filled with the same gray used in the sky. The spatula should be held flat and horizontal to create a flat surface without any traces of impasto.

4. The foreground has an orange base. A second color was added immediately, a light green this time. There is no blending with spatulas, and barely any transition between one color to another. Work must be quick; act while the layer of paint is still wet.

4

5

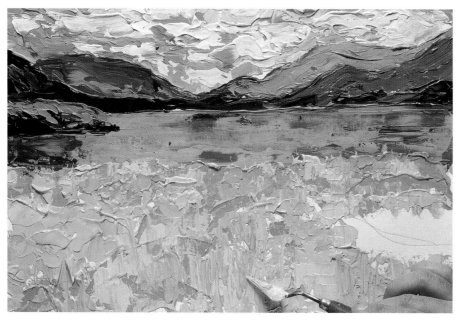

5. The vegetation is finished by applying vertical yellow strokes with the tip of the spatula. These marks give a general impression of varied and diverse vegetation rather than an overly detailed representation. Any attempt to add detail to the bushes is bound to fail.

A

THE ARTIST FINISHES

Impastos created with spatulas, with frenetically overlaid streaks of color, give the painting great vitality. Each fragment could be an abstract painting (A). In the vegetation in the foreground there is more gesso mixed with the paint, which is needed to give it volume so sgraffito can be made with the tip of the spatula (B). Only yellow should not be mixed with gesso; it must look warm and pure, and when it is mixed it becomes too pale (C).

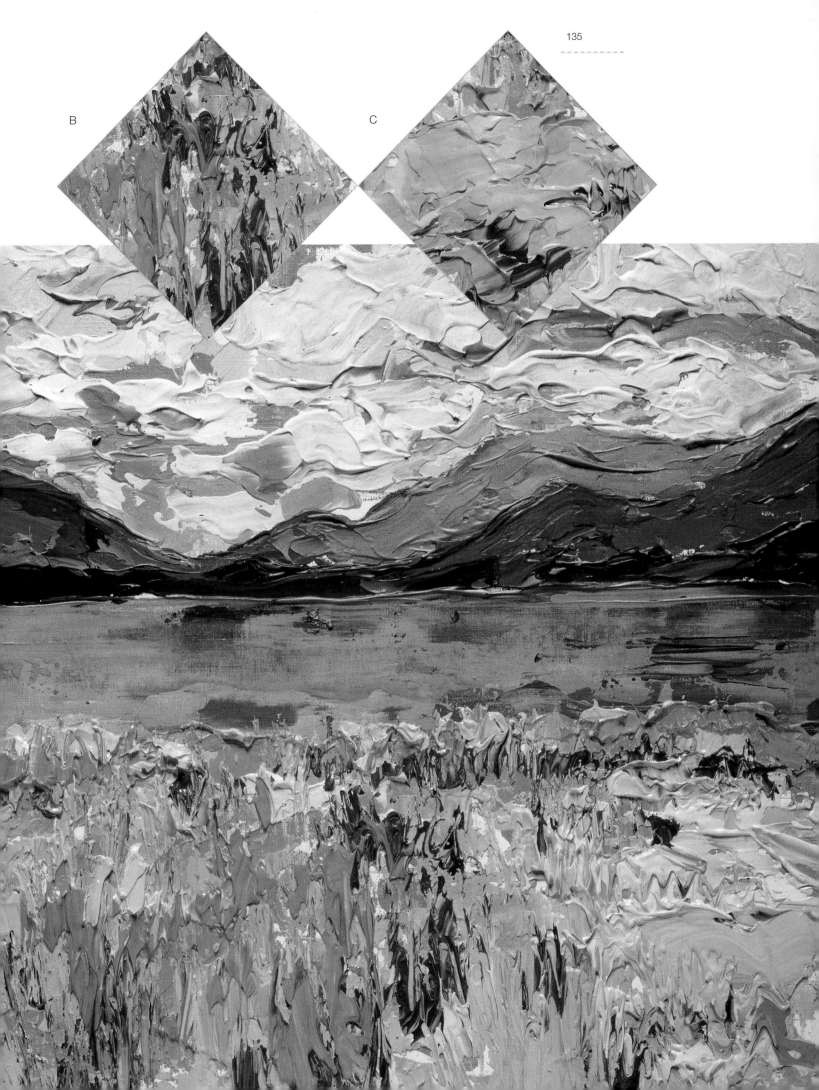

B

C

An Impasto Forest: Fillers

Let's go even farther in the creation of surfaces and textures with acrylic paint, which is one of the best media for use with fillers. In this technique the paint is mixed with modeling paste, which will increase its volume without changing the color. The following painting, created by Almudena Carreño, was made entirely with modeling paste of different densities, creating a complex surface with very interesting relief and textures.

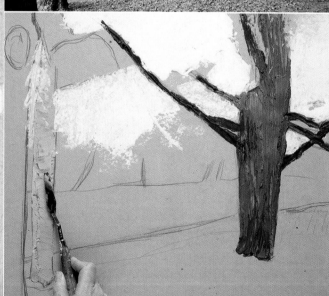

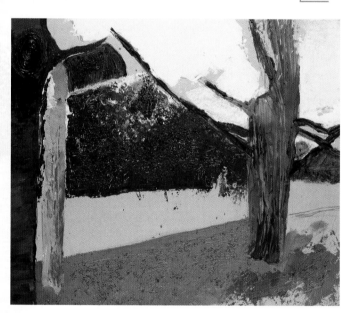

1. The drawing will be extremely concise, since it loses its detail when the first layer of impasto is applied. The sky is gesso mixed with a small amount of ultramarine blue, applied with the back of a spatula. Modeling paste mixed with brown and ochre is used to cover the tree trunks with up and down strokes.

2. The trunk on the left with the darker brown is made with a finer modeling paste. You should add a certain amount of texture; no need to use only the flat back of the spatula like when the green was added for the grass. Use the edge to make thin, somewhat precise lines.

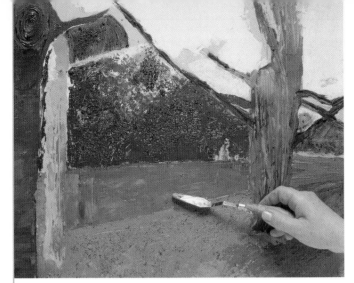

3

3. The function of the first color layers is to create the general tones, so they should be applied relatively thin on the water scene and the background vegetation. The best way of working is by mixing the colors on the palette first; then add the filler to the mixture.

4. Allow the first layer of impasto color to dry before applying a second layer. Then prepare a very light green, mix it with fine filler, and spread it over the grass. The leaves are covered with new variations of green and ochre, with small loose strokes in different directions.

The paint seems to lighten when it is mixed; this is because the modeling paste is white. The final color will be darker when it dries, so often times it is difficult to judge the strength of the color.

4

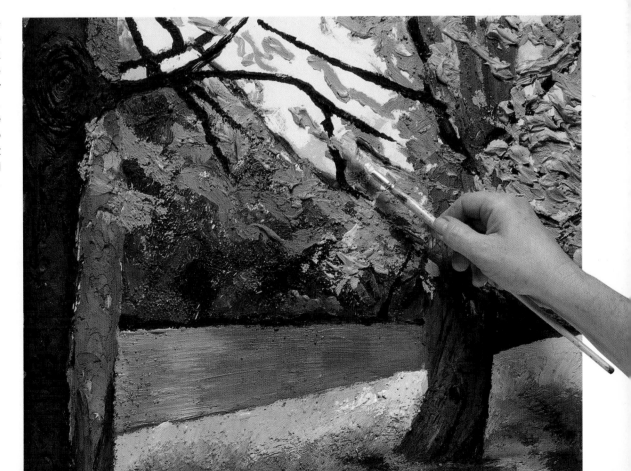

5. The modeling paste used for painting the leaves should have a fine filler. Mix it with the paint and a little water to make it creamier. You will be able to use a round bristle brush to apply brushstrokes that will look gestural and lively.

5

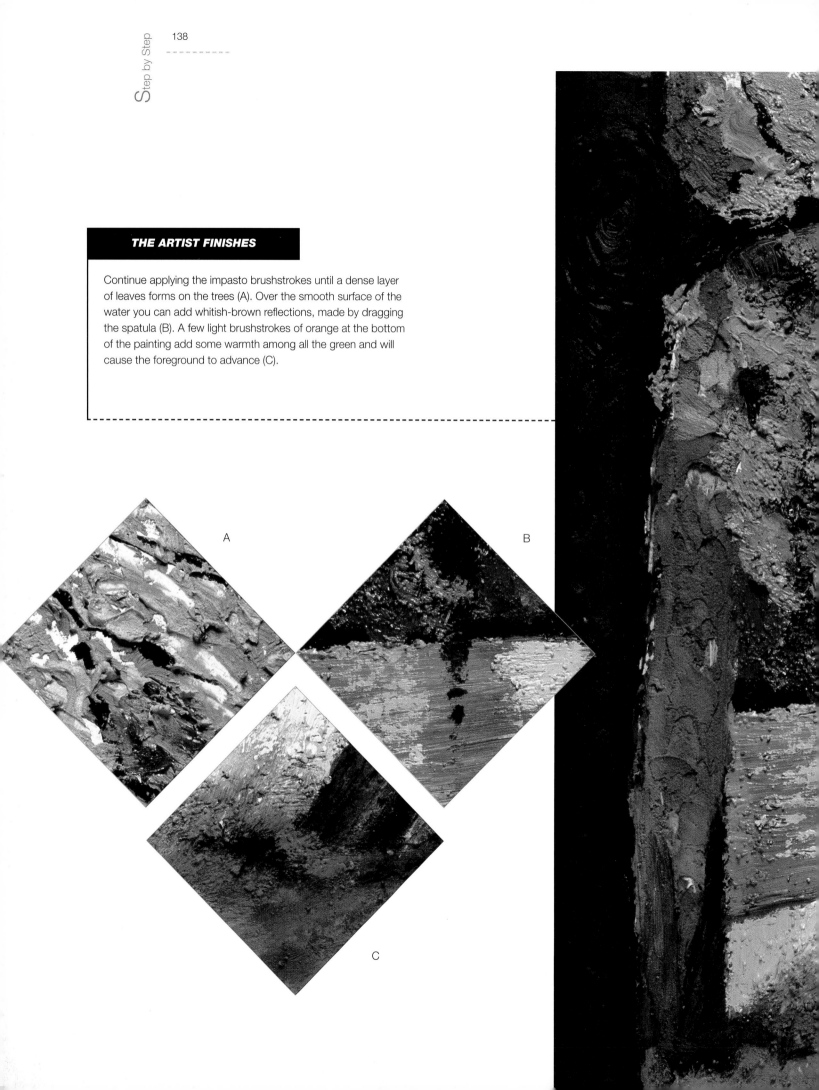

THE ARTIST FINISHES

Continue applying the impasto brushstrokes until a dense layer
of leaves forms on the trees (A). Over the smooth surface of the
water you can add whitish-brown reflections, made by dragging
the spatula (B). A few light brushstrokes of orange at the bottom
of the painting add some warmth among all the green and will
cause the foreground to advance (C).

A

B

C

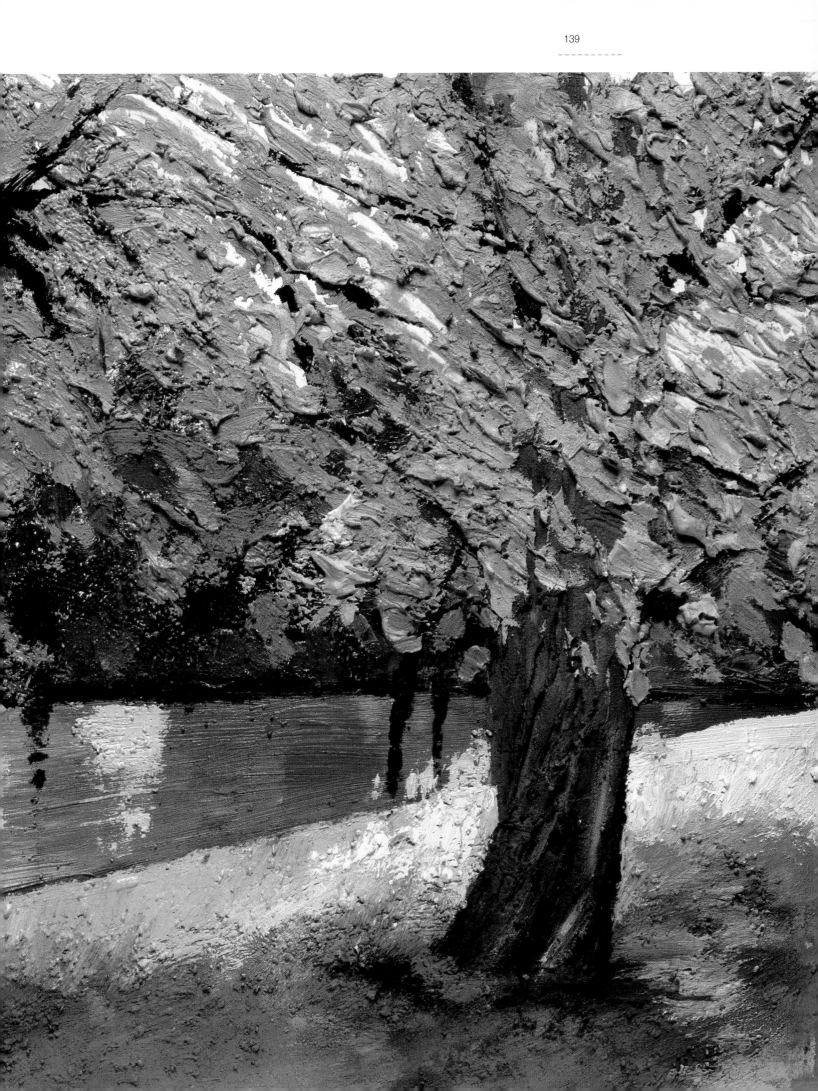

Colorist Composition with Puddles

Architecture is a very popular theme in painting. The subject of the next exercise is a fragment of a building with beautiful shining cupolas. Models like this give you a break from complicated urban perspectives and let you focus on exploiting the colorful scene with saturated tones. Gabriel Martín approached this exercise using the puddle technique. This is a slow technique that requires a couple of days to finish the work.

1. The pencil drawing is very general and informal paying little attention to correct perspective, and it even leans toward a stylized and exaggerated interpretation. The paint is applied very wet, generously covering each area.

2. The puddles, which are nothing more than thick washes, cover the largest areas of the painting first. When the sky is painted with blue the color is distributed unevenly, forming puddles. The paint is not as densely applied where the clouds are to appear.

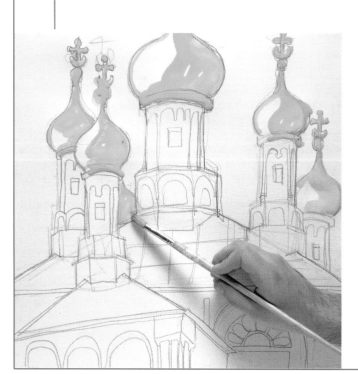

When painting with the puddle technique the support should always be kept flat. If it is inclined it will cause dripping, or worse, accidental mixing of the colors.

3

4

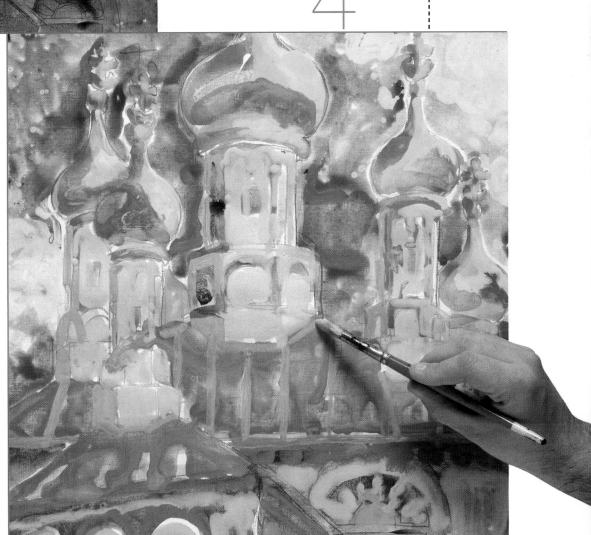

3. The building is painted with different shades of brown and gray. Use a medium round brush and limit the flow of the wash in each area. Be careful not to touch the still-wet washes in the sky with the brush because the colors can flow together and mix. Allow the paint to dry for two or three hours.

4. When the colors have dried lay new puddles over the old ones. Fill in the white of the towers with pink, yellow, and blue tones; finish the mass of the cupolas with reds and the roof with violets.

5. After applying several layers of washes you will have a very colorful representation. At this point it is a good idea to let the painting dry completely for another two or three hours. Later, outline the subject with black paint and a fine round brush to create a stronger graphic effect.

5

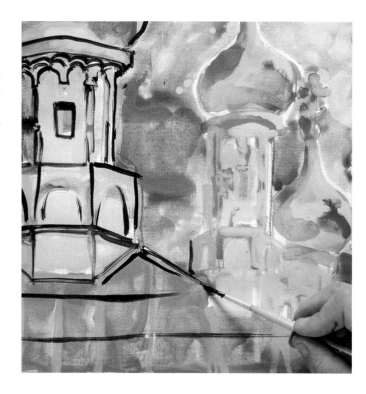

THE ARTIST FINISHES

Outlining with black adds a more graphic style and dynamism to the painting. Be careful; you do not want to completely outline all the shapes; you should leave some areas untouched (A). It is not necessary to precisely describe the architectural elements, just a light asymmetric line will do the trick (B). The colors radiate vitality and richness. The most yellow tones in the illuminated areas contrast with the blues of the shaded parts of the towers (C).

A

B

C

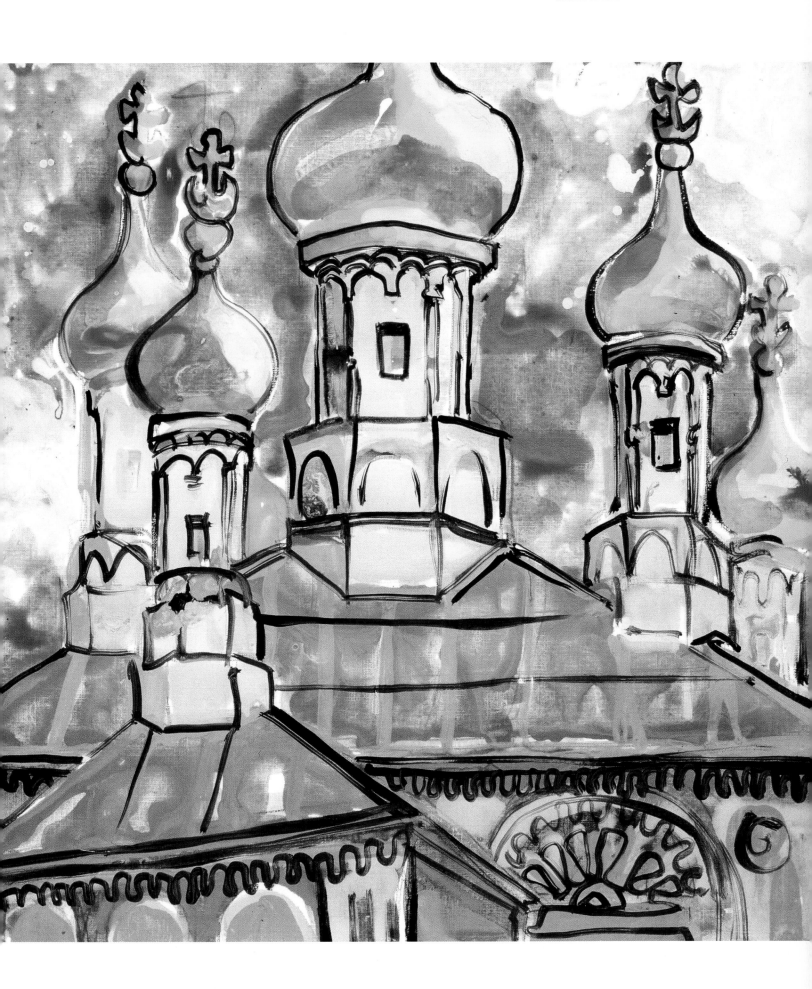

Painting people usually seems much more difficult than it really is. This is because the human form is often regarded as an academic theme, and its artistic treatment is considered to be more difficult than any other subject.

Gabriel Martín selected a simple colorist composition so that you will not feel too intimidated to try this exercise. He gave it a loose treatment, constructing the figures with a few brushstrokes without being too precise. The base consists of colored paper glued to the support to reinforce the modern and relaxed approach.

Figures with Colored Paper and Acrylics

1. Cut out a few pieces of colored paper. The shapes should be geometric. The area of the bed is covered with the brown and violet papers, glued with latex. Then glue pieces of green and orange heavy paper in the place occupied by the figures.

1

2

A fine round brush will be your best tool when making the drawing. The paint you use should be mixed with a lot of white so it will be more opaque and contrast strongly with the background colors.

2. Allow the paper collage to dry before beginning to draw with a graphite pencil. The lines are then strengthened with a little bluish paint. We chose this color because it contrasts strongly with the colored paper background.

3

3. Shading is done with a square tip brush containing dark brown paint. It is not a matter of creating a chiaroscuro effect or of making gradations. You should just paint, applying brushstrokes wherever you see the presence of a shadow, no matter what color it is.

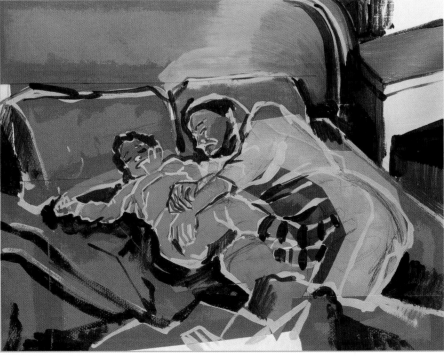

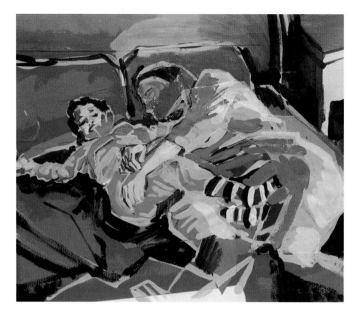

4. Now the figures must be painted. Using rose mixed with a little yellow, paint only the illuminated parts of the skin tones. Do the same to the clothing with green mixed with white and yellow. Medium green completes the shaded areas of the woman's pajamas.

4

A

THE ARTIST FINISHES

The lightest parts of the sheets are painted with a rose tone, following the direction of the folds (A). If you look at the faces of the figures you will see how they have been resolved with just a few strokes of ochre and rose mixed with white (B). The brushstrokes are short, spaced apart, and constructive, avoiding covering completely the color of the glued papers. It is important to allow their colors to show through the painted areas (C).

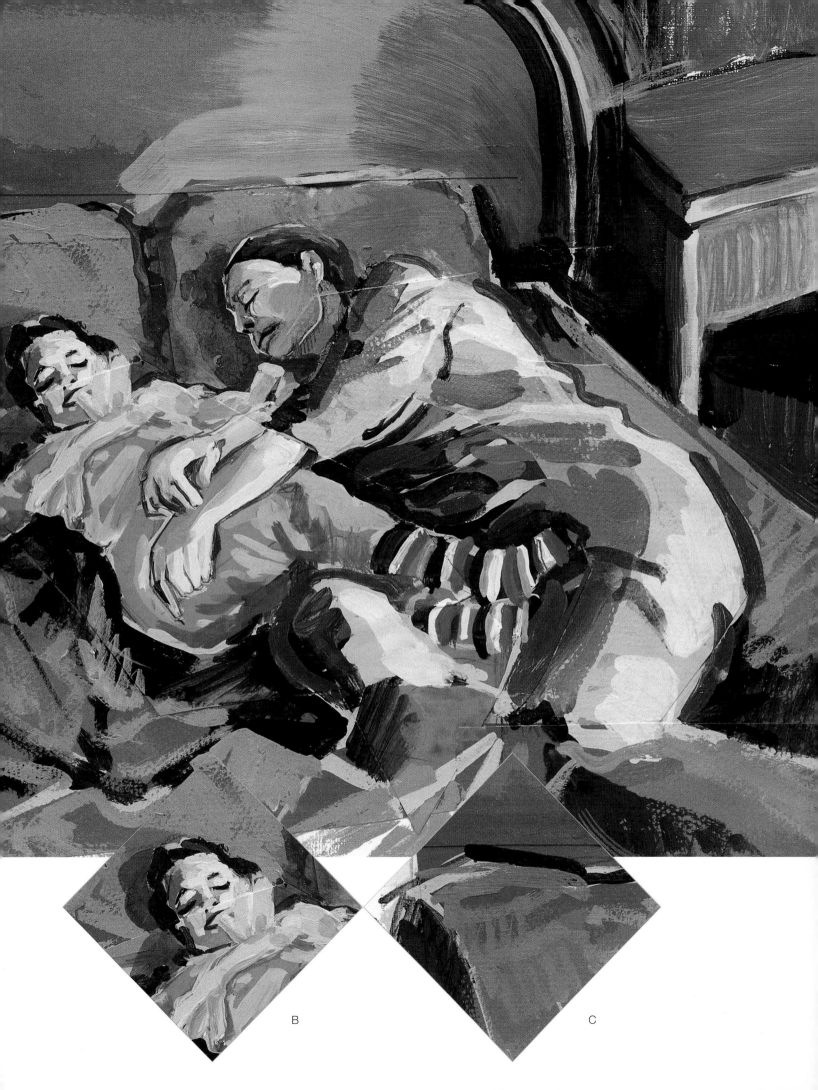

B

C

The next exercise is somewhat more complex than the last ones. We are going to use two presumably incompatible media on the same support, oil pastels (with an oily base) and acrylic paint (with a water base). Study how Gabriel Martín uses the acrylics more or less diluted according to the working phase. This is definitely a good example of how to make paintings a little more elaborate with bright colors.

Colorist Still Life with Acrylics and Oil Pastels

1. The preliminary sketch is made with a blue crayon. The line is rhythmic, flowing, and deliberate. It attempts to indicate the main outlines of the elements that constitute the still life. The sketch is drawn on white paper.

2. As the drawing progresses other colors are added to complete the shapes of the elements. Remember that these lines will be visible even after the painting is finished, so they are important.

3. After the line sketch of each element is completed, they are shaded with colors and reserves are added with a white pastel crayon. The areas covered with white will resist the acrylic, and the color wash will appear lighter there than in the rest of the painting.

1

2

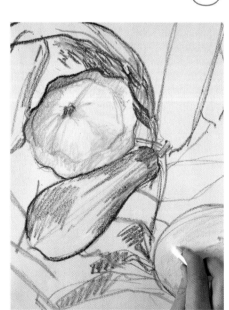

3

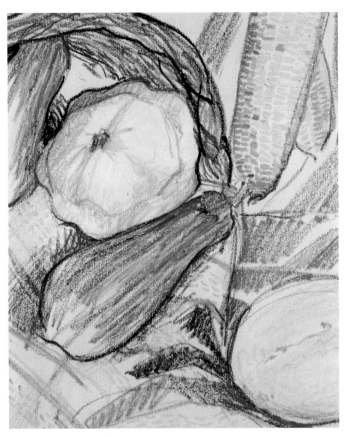

4. The drawing is already halfway finished. If you stopped here it would be enough. The lines and the colored areas will be more or less visible once they are covered with color washes.

5. The color is prepared on the palette with soft hair brushes like those used for watercolors. It is diluted with a lot of water and the largest areas are painted, beginning with the background, the ear of corn, and the eggplant. Notice how the watery diluted paint runs off the wax lines, which are still visible.

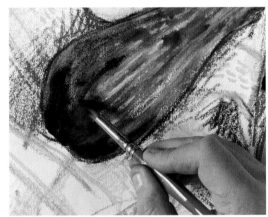

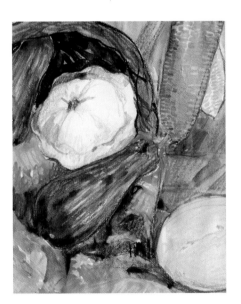

6. The washes are still large. Now the main objective is covering the white of the paper with new additions of watery paint on the yellowish gourd, the basket, and the orange cloth. Be careful with the last one. On it the color washes are not uniform but mixed, from the beginning, using browns and orange tones.

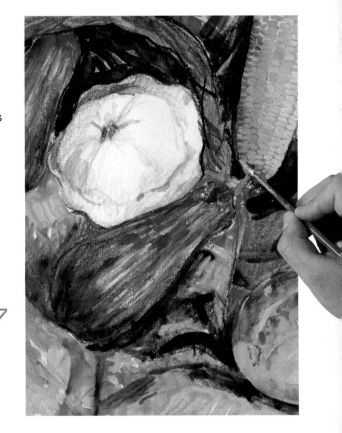

7. After the general tones are in place, begin creating contrasts. This is done by darkening the inside of the basket, the shaded areas in the background, and the bases of some of the produce with dark washes. The ears of corn are finished detailed with thicker opaque paint, using pointillism that ranges from orange tones to light yellow.

8. The pattern on the orange cloth is painted with the same brush you used to paint the kernels of corn. To finish, you can return to painting shadows and new linear details with oil pastels on the dry acrylic.

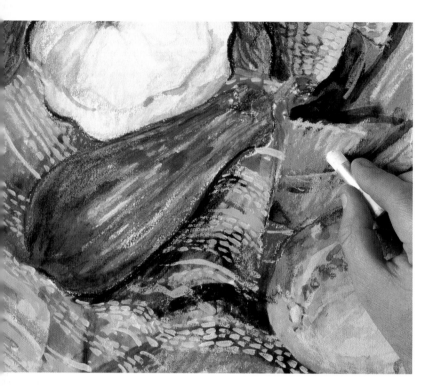

8

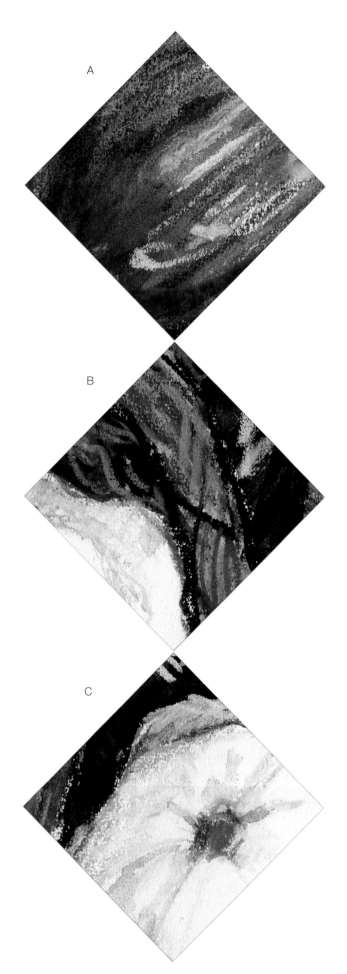

A

B

C

THE ARTIST FINISHES

In the finished painting you can see a lively combination of very attractive forms and textures. The final touches with white pastel consisted of applying reflections on the eggplant (A). The interesting thing about this technique is that the texture of the lines is still visible through the washes (B). The lines very subtly explain the volume of the white gourd (C).

Seascape
with Dragging

For a final exercise, we have decided to paint a coastal scene using the dragging technique, which means spreading the paint with a flat wide spatula. This technique will be combined with some final impasto effects to add more volume in the foreground. The best way of working with dragged paint is to keep in mind that you are creating a general impression of the theme instead of a detailed version. Remember that working with a spatula does not lend itself to meticulous work, but rather constructing the painting with more or less wide strokes of color. The artist painting this exercise is Gabriel Martín.

1. The shapes of the main elements of the composition are defined very clearly using a 2B pencil, with hard edges and clearly drawn lines. Do not worry about precision, since the paint will eventually cover the lines.

1

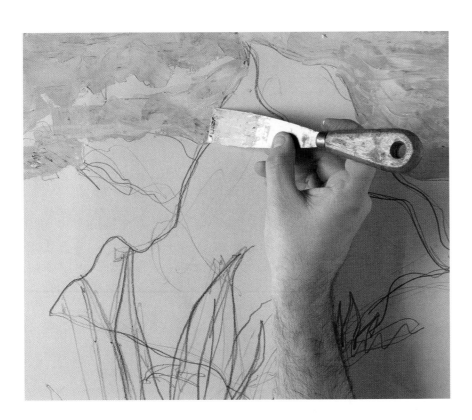

When preparing paint for dragging it is a good idea not to mix it too much. This way the spatula will create very attractive streaks.

2

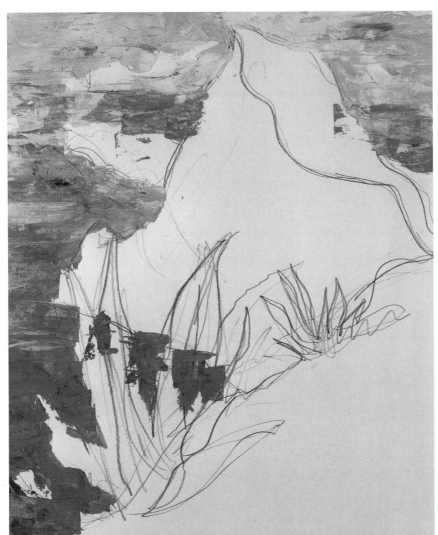

2. Begin by painting the blue sea in the background. Cyan blue, ultramarine blue, and white are mixed in unequal proportions on the support so they will form streaks. Press hard on the spatula to create a very thin glaze in the first layers. Transparent pigments should be used.

3. After the water is finished make sure it shows a clear tonal gradation, with lighter blues at the top and darker ones at the bottom. A larger amount of ultramarine blue and carmine is used to darken the blue and give it a slight violet tone.

3

4. The areas covered with vegetation are painted with a little ochre green and brown. If you mix several colors in each application, especially in the initial phases, the painting will have a lively base and impart spontaneity during the rest of the work.

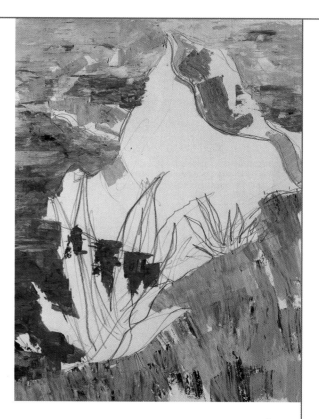

4

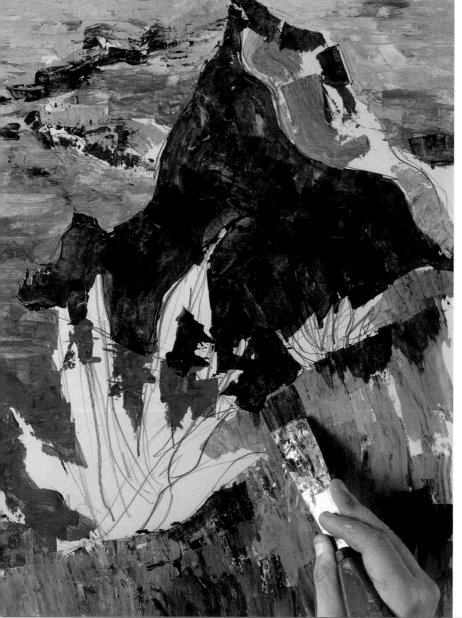

5

5. Now it is necessary to create a dark color to paint the shaded face of the rock. To accomplish this, mix carmine, ultramarine blue, and a small amount of dark green on the palette. Cover the whole surface with the mixture, moving the spatula freely and in different directions.

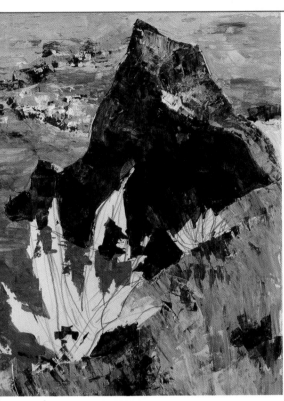

To create the leaves it is necessary to make small well-defined applications of color. Be especially careful with the points of the leaves. Practice on a separate sheet of paper.

6. Complete the vegetation at the top of the rock and the cliff with touches of overlaid and broken paint. The first combines ranges of greens and oranges and the second with a base of ochre overlaid with streaks of intense violet.

7. The vegetation in the foreground is finished with thicker paint; this will make it more prominent. Charge the point of the spatula with paint, angle it, and press while dragging it a very short distance. This is repeated for each leaf.

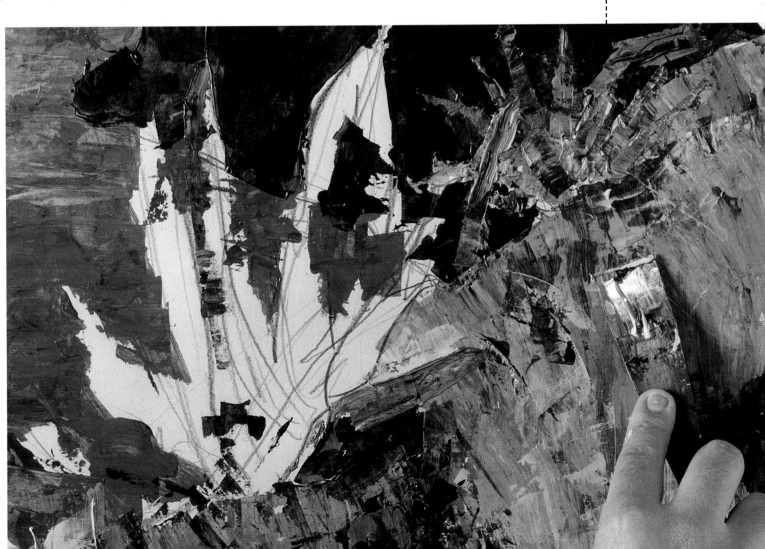

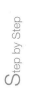

8

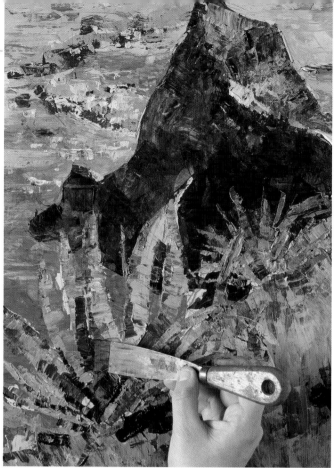

8. Apply some yellow (slightly brighter in tone) impasto with more paint, if possible, over the first green color. You should make the long leaves display several colors and place some in front of the others. The outlines should be very clear and differentiated from the blue background.

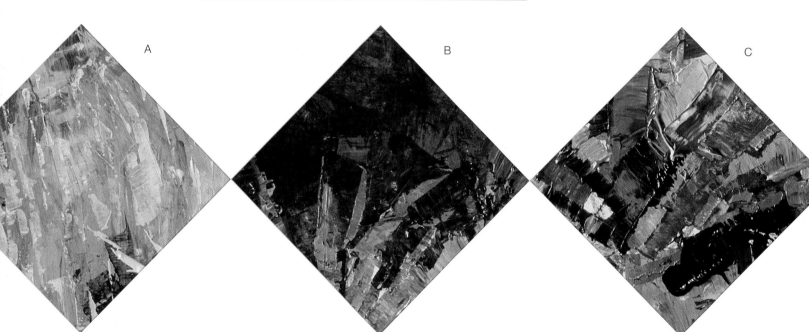

A

B

C

THE ARTIST FINISHES

To finish the exercise, focus solely on the vegetation in the foreground. Draw lines in the grass with ochre, yellow, and orange (A), and with a very dark violet darken the shadow on the rock (B). The finished painting shows a great variety of effects that are impossible to create with any traditional painting tool. The thin glazes of dragged paint contrast with the discrete semi-impastos and hard edges of the vegetation in the foreground (C).

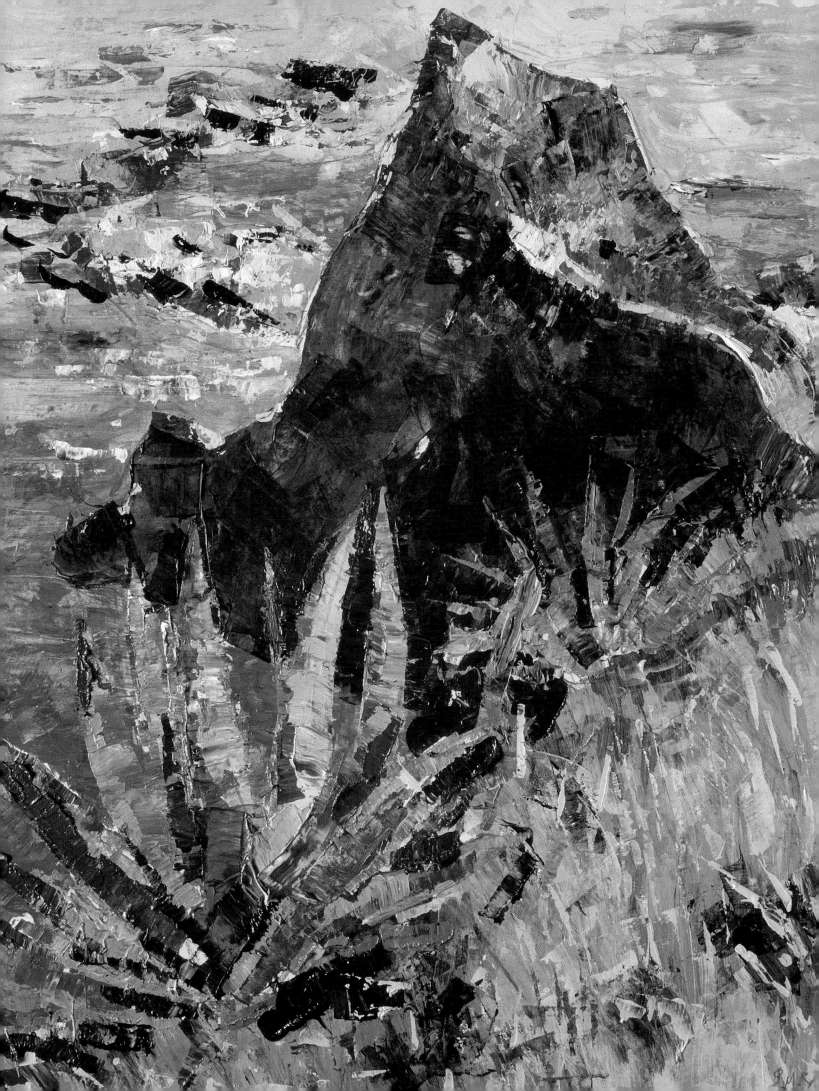

A

Acrylic. A resin derived from a chemical compound or propenoic acid produced from petroleum.

Agglutinate. A liquid substance that is mixed with a powdered pigment to make paint that will adhere to a support.

Alla prima. A direct painting technique that can be described as painting in a single session, quickly and without going back over the work.

B

Base. A surface that is prepared or primed for painting.

Bas-relief. A work in which figures project slightly from the background and no part is entirely detached from the background.

Blending. The continuous transition of one color to another made with a systematic application of oil pastels or paint.

C

Chiaroscuro. A painting technique based on modeling objects with saturated local color. The contrasts in chiaroscuro are of value (light and dark tones) more than color.

Chromatic range. A series of colors, or a series of shades of the same color.

Collage. A technique consisting of pasting diverse materials on the surface of a painting, like paper, fabric, or objects of different shapes and colors.

Crepe paper. Paper with crinkled or puckered texture.

D

Drop. The minimum amount of paint needed to influence a color with which it is mixed, without actually changing it.

Dry brush. A painting technique of applying thick undiluted paint to the support. This method creates a better effect if the support being used has a heavy texture.

F

Filler. An inert powder that is added to the paint to increase its volume, opacity, or texture. The increase in texture is determined by the granularity of the material.

G

Gel. A substance that is mixed with acrylic paint to strengthen or increase its viscosity and consistency.

Gesso. Originally a mixture of glue and calcium carbonate, today it is usually a white pigment agglutinated with acrylic medium.

Glaze. A layer of transparent color that creates a new tone when painted over a color.

Gradation. Changing the saturation of a color through progressive lightening or darkening of its tint. This technique is used a lot in chiaroscuro painting.

Grain. The texture, heavy or light, of a piece of paper or canvas.

H

Highlight. This is generally a reflection, the lightest shade of the paint.

I

Impasto. The application of thick paint with the intention of creating a textured area in a work of art. Impasto can be applied with a brush or spatula.
Intensity. The amount of saturation of a color, its purity, and brightness.

M

Medium. An additive that is combined with paint to control the properties and consistency of the color.
Mixed techniques. This refers to the use of different media in a single work of art, for example, watercolor and acrylics, collage, acrylics and pastels, or acrylics and oils. Acrylic paint lends itself to mixed media work.

O

Opacity. The ability of paint to cover another color below it.

P

Painting on wet (wet on wet). Painting over an area recently dampened with water, or recently painted and not yet dry. The wetness can be controlled by the artist according to the desired forms and effects.
Pigment. A natural or synthetic powder that supplies the color in the recipe for paint. Quality paint will have the exact color of the pigments used in their manufacture.

Primer. The first layer of pigment on the surface of a support that prepares it for subsequent painting.

R

Retarder. An acrylic substance that is mixed with paint to slow its drying time.

S

Saturation. The level of intensity of a color. It is at its maximum saturation when it leaves the paint tube.
Scrubbing. Making color marks by rubbing a nearly dry brush on the paper or canvas.
Sgraffito. A technique consisting of scraping a layer of paint while it is still wet to leave marks or lines or to reveal the color that is underneath.
Shading. The painting technique used to create different levels of light and shadow by lightening or intensifying the values on the object.
Sketch. A simple drawing or painting with few details. It is used as a study for the composition and guidance with the later work.
Spatter. This technique consists of splashing drops of paint, by rubbing the bristles of a brush or toothbrush that has been loaded with paint diluted with water.
Spatula. A flexible metal blade with a wood handle used for working with impasto and dragging paint on the surface of the painting.

Striated paint. A decorative technique that imitates wood grain. This is created when the brush, when dragged, leaves small lines where several mixed colors can be seen.
Support. The surface used for painting, for example, fabric, paper, wood board, or cardboard.

T

Texture. The tactile appearance of the paint on a work of art. The texture can be smooth, rough, grainy, streaked, etc. They are created by manipulating the paint or by adding fillers to the paint.
Transparency. This is a characteristic of paint that allows the support or paint that is underneath to show through. Transparent colors can be made opaque by adding a small amount of white paint.

U

Underpainting. The initial stage of a painting characterized by the general and approximate distribution of color. The aim is to cover the entire surface and to appreciate the general effect of the painting.

W

Wash. A thin layer of paint diluted with water to form a translucent glaze.
Wet palette. A palette designed specifically for acrylic paint to preserve its humidity and keep it from drying.

ossary

PAINTING CLASS

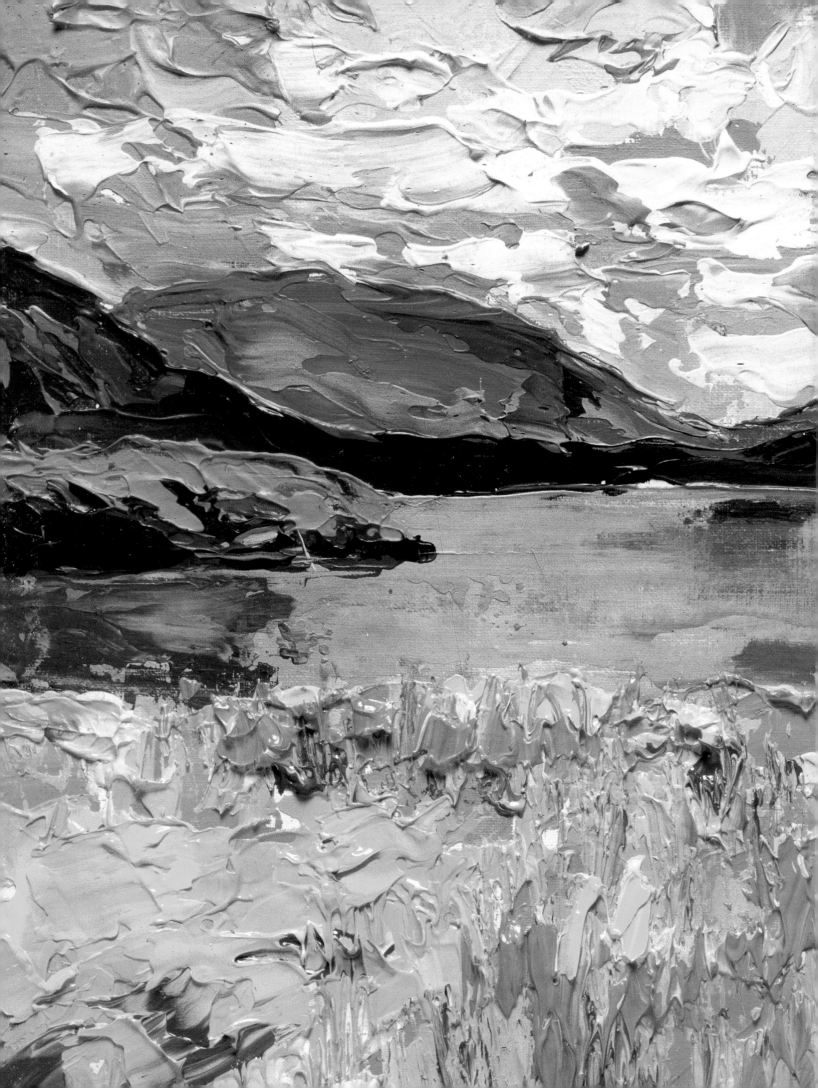